50 Florida Wildlife Hotspots

Key West to the Panhandle

A Guide for Photographers and Wildlife Enthusiasts

by
Moose Henderson

Sastrugi Press
Jackson, WY

Sastrugi Press / Published by arrangement with the author
50 Florida Wildlife Hotspots: Key West to the Panhandle

The author has made every effort to accurately describe the locations contained in this work. Travel to some locations in this book may be hazardous. The publisher has no control over and does not assume any responsibility for author or third-party websites or their content describing these locations, how to travel there, nor how to do it safely. Sketch maps provided are approximate. Refer to official government maps.
Any person exploring to these locations is personally responsible for checking local conditions prior to departure. You are responsible for your own actions and decisions. The information contained in this work is based solely on the author's research at the time of publication and may not be accurate. Neither the publisher nor the author assumes any liability for anyone exploring, visiting, or traveling the locations described in this work.
Sastrugi Press
PO Box 1297, Jackson, WY 83001, United States
www.sastrugipress.com
Quantity sales: Special discounts are available on quantity purchases by corporations, associations, and others. For details, contact the publisher at the address above.

Library of Congress Cataloging-in-Publication Data
Names: Henderson, Moose, author.
Title: 50 Florida wildlife hotspots Key West to the Panhandle : a guide for
 photographers and wildlife enthusiasts / by Moose Henderson.
Other titles: Fifty Florida wildlife hotspots Key West to the Panhandle
Description: Jackson, WY : Sastrugi Press, [2021]
Identifiers: LCCN 2021036333 (print) | LCCN 2021036334 (ebook) | ISBN
 9781649222190 (hardback) | ISBN 9781649222206 (paperback) | ISBN
 9781649222213 (ebook)
Subjects: LCSH: Animals--Florida. | Animals--Florida--Identification.
Classification: LCC QL169 .H46 2021 (print) | LCC QL169 (ebook) | DDC
 591.9759--dc23
LC record available at https://lccn.loc.gov/2021036333
LC ebook record available at https://lccn.loc.gov/2021036334

Summary: Discover the best wildlife photography locations in Florida from Key West to the Panhandle.

ISBN-13: 978-1-64922-219-0 (hardback)
ISBN-13: 978-1-64922-220-6 (paperback)
ISBN-13: 978-1-64922-221-3 (ebook)

Printed in the United States of America when purchased in the United States

All photography, maps and artwork by the author, except as noted.
10 9 8 7 6 5 4 3

CONTENTS

FOREWORD

As a wildlife photographer myself, I was excited to see that my incredibly talented friend and colleague, Moose Henderson, is releasing yet another tremendous wildlife guide for photographers.

Calling *50 Florida Wildlife Hotspots: Key West to the Panhandle*, a "wildlife guide" is perhaps a misnomer because the book is so much more than a guide. *50 Florida Wildlife Hotspots: Key West to the Panhandle* is a literal road map for successfully observing and photographing Florida wildlife from wading birds and reclusive American crocodiles to raptors and tropical reef systems.

As many readers will know, Florida offers a vast diversity of flora and fauna that draws flocks of birders and wildlife photographers year round. However, just because the state is teeming with wildlife, doesn't mean that wildlife is easy to find *or* photograph. As experienced wildlife photographers know, regardless of how skilled the photographer and how sophisticated the photographic gear, if the subject cannot be located, the experience will be frustratingly disappointing. Knowing when, where and how to find a particular subject is key to successful wildlife photography. Additionally, arriving prepared for the environment and knowing what potential hazards may be presented in photographing the subject is imperative for a safe and rewarding shoot.

Normally, accruing the information needed to safely find and photograph Florida's wildlife would take endless hours of research, in-field experience, local knowledge and a great deal of patience. However, Moose Henderson makes a wildlife photographer's quest to create amazing imagery of Florida's wildlife just that much easier with *50 Florida Wildlife Hotspots: Key West to the Panhandle*.

Moose Henderson's extensive experience as a wildlife biologist, environmental geologist, successful wildlife photographer, former Floridian of 25 years and his willingness to share his knowledge is evident in the contents of *50 Florida Wildlife Hotspots: Key West to the Panhandle*. The book includes easy-to-follow maps and site-specific locations for places where wildlife is abundant. Important species-specific notes in regard to behavior and habitat, along with site-specific photography equipment tips, keep the odds in the photographer's favor for successful viewing. The book includes park fees and hours for each of the 50 hotspots noted.

With the author's easy-to-follow and informative writing style, included illustrations, maps and photography, *50 Florida Wildlife Hotspots: Key West to the Panhandle* is designed for the photographer and nature enthusiast alike. This book is sure to become the volume people reach for when wanting to significantly increase the opportunity of viewing some of the most extraordinary wildlife and habitats imaginable.

Karen Doody, Fellowship of Photography,
Professional Photographers of North Carolina

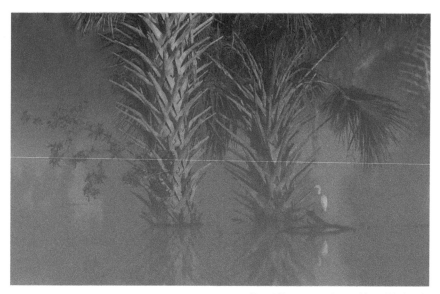

Great Egret preening at Viera Wetlands

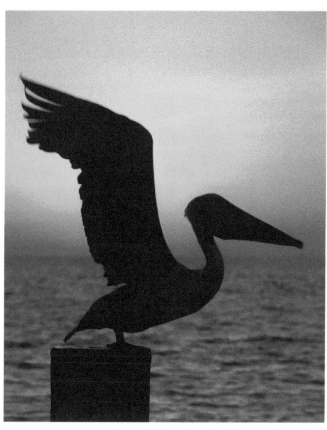

Brown Pelican wing stretch on post at sunrise.

INTRODUCTION

In many ways, Florida is a unique state. Many of these unique qualities make Florida an ideal destination for wildlife enthusiasts and photographers. Florida has nearly 1,200 miles of coastline and Florida is home to 175 state parks, three national forests, and 12 national parks, seashores, monuments and preserves.

Florida is the only area with both alligators and crocodiles. The Everglades contains 1.5 million acres of subtropical wilderness. Kissimmee State Park is the only state park certified by the International Dark-Sky Association. The tropical nature of Florida, combined with the coastline, makes Florida an ideal location for wildlife.

Over 500 species of birds are found in Florida. Numerous endangered species also visit or live in Florida including sea turtles, manatees, panthers, black bears, tortoises and many birds. Florida is renowned as a mecca for bird photography. Not only are the birds plentiful, but many are also very habituated to humans allowing excellent images.

North and Panhandle

Central

Southeast

Suncoast or Southwest

South

Fifty Florida Wildlife Hotspots is a selection of locations throughout the state. Some of the places are well known for wildlife and wildlife photography. Other locations are a bit more obscure. Locations have been divided into five regions: Suncoast or Southwest, South, Southeast, Central and North (including Panhandle). No matter which location you visit in the state, there will be a wildlife hotspot within a few hour's drive.

The Suncoast or Southwest region includes ten counties: Pinellas, Hillsborough, Manatee, Sarasota, DeSoto, Charlotte, Glades, Lee, Hendry and Collier. This region includes the major metropolitan areas of Tampa Bay (Tampa, Clearwater and St. Petersburg), Sarasota, Ft. Myers and Naples. Hotspots 1-18 are located in the Suncoast region.

The South region includes only two counties, Monroe and Dade. This region includes the major metropolitan area of Miami in addition to the Everglades and the Florida Keys. Hotspots 19-25 are located in the South or Southern region.

The Southeast region includes six counties: Broward, Palm Beach, Martin, St. Lucie, Okeechobee and Indian River. This region includes the major metropolitan areas of Ft. Lauderdale, Boca Raton, and Palm Beach. Hotspots 26-30 are located in the Southeast region.

The Central region includes thirteen counties: Brevard, Seminole, Osceola, Orange, Highlands, Hardee, Polk, Lake, Sumter, Pasco, Hernando, Citrus and Marion. This region includes the major metropolitan areas of Orlando, Ocala, Lakeland, and Melbourne. Hotspots 31-42 are located in the Central region.

The North region includes thirty-six counties. The Panhandle section consists of Escambia, Santa Rosa, Okaloosa, Walton, Holmes, Washington, Jackson, Calhoun, Bay, Gulf, Gadsden, Liberty, Franklin, Wakulla, Leon and Jefferson. The Northeast section includes Madison, Taylor, Hamilton, Suwannee, Lafayette, Dixie, Columbia, Levy, Gilchrist, Alachua, Bradford, Union, Baker, Nassau, Duval, Clay, St. Johns, Putnam, Flagler and Volusia. This region includes the major metropolitan areas of Jacksonville, Tallahassee and Pensacola. Hotspots 43-50 are located in the North region.

Although the North region has the most counties and land area, the Suncoast, Central, Southeast and South regions contain the greatest concentration of visible and photographable wildlife. These areas are productive and are well worth the effort to travel to for wildlife photography and viewing.

Hotspots: Each hotspot listing includes the site address. Most vehicles and cellular phones have a GPS so the book does not include directions unless there were specific details that were unclear with GPS directions. When available, each hotspot also includes a phone number and website address.

Fees and hours of operation are included as a guide but these are subject to change. Also included are toll booths and parking fees, when these are near the hotspot.

A short description of the hotspot is included and some of the wildlife that could be encountered. Most animals and birds are most active in the early morning and late in the day. During the heat of the day, animals tend to "hide" under cover. For best viewing and photography, the best hours are a few hours at dawn and the few hours at dusk.

Photography tips are given for each hotspot. These are general recommendations and procedures that have worked well for me. I lived in Florida for over 25 years and have visited each of these hotspots many times.

A diagram is provided with most hotspots. This is provided to give you a rough idea of the layout of the area; more detailed diagrams and maps are available from most of the websites provided.

Safety: Generally, Florida is a relatively safe area. It does not have the danger of grizzly or polar bears, there are no bison roaming free in the meadows (except at Paynes Prairie), and there are no hungry tigers roaming the Serengeti. However, Florida does have panthers, black bears and numerous alligators. Exercise caution when you are viewing and photographing wildlife. Even though much of Florida wildlife is habituated, never forget that the wildlife is indeed wild.

Florida also has its share of crime. Exercise extreme caution with camera equipment and other valuables. Go with a friend to view or photograph wildlife or carry some means of protection, if you feel it is appropriate.

I carry a change of clothes and shoes in my vehicle. It is not unusual to get wet crossing narrow lagoons or photographing shorebirds. It seldom snows in Florida but it rains nearly every day in some areas. I also carry plastic bags in my pocket to protect my gear from the torrential downpours.

Egmont Key Lighthouse

MY FIELD NOTES:

SUNCOAST OR SOUTHWEST REGION
COVERING HOTSPOTS #1-18

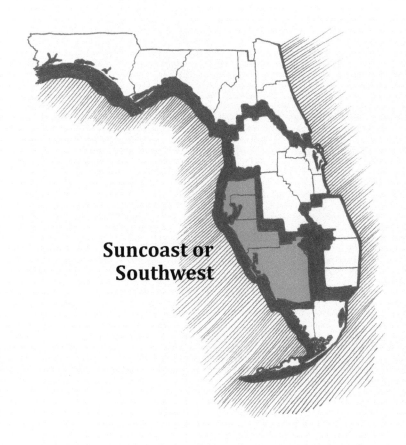

Suncoast or Southwest

Honeymoon Island State Park, Dunedin, FL (Pinellas County)

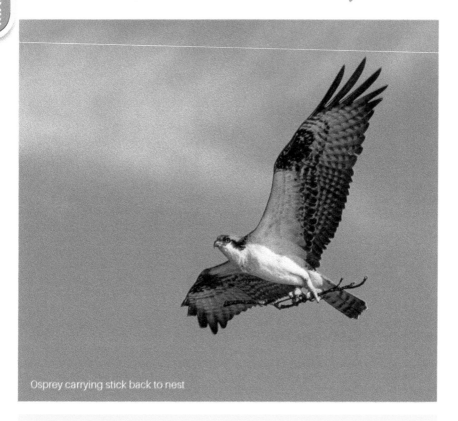
Osprey carrying stick back to nest

Site Specifics:

Honeymoon Island State Park, 1 Causeway Boulevard, Dunedin, Florida.
Telephone: 727-241-6106.
Website: https://www.floridastateparks.org/honeymoonisland

Fees: Park entrance requires payment of a fee that depends on the number of occupants in your vehicle. Entrance fees for one person per vehicle are $4, two to eight persons in a single vehicle are $8 and pedestrians or bicyclists are $2. An annual state parks pass is available for Florida Parks; it is an excellent value if you plan many visits to the state parks.

Hours: The park is open from 8 am to sunset, 365 days per year. Fees and hours of operation were current at the time of publication but subject to change; check the website for updates.

DESCRIPTION:

Honeymoon Island State Park is a 2,800-acre state park that is part of the barrier islands on the west coast of Florida. The island is named Honeymoon Island because Life magazine held contests for newlyweds with a prize of a two-week stay on the island.

Honeymoon Island is a long narrow island with the long axis-oriented NW to SE. Public beaches, known as North Beach, Oasis Beach, Main or South Beach, and Pet Beach are located on the southwest or gulf side.

Two nature trails, the Osprey Trail (near the north beach area) and the Nature Center Trail (near middle beach area) wind through mangrove and pine forests. Osprey and Great Horned Owls are relatively common on the Osprey Trail that winds through the pine flatwoods. Watch your footing as rattlesnakes also share the island with the birds. Many overwintering migrates use the island for feeding and rest.

Many brown pelicans have been seen nearby feeding in the gulf waters. The beaches attract many shorebirds and a few wading birds. The beaches are a mixture of white sand, seashells, and palm-sized limestone rocks. During high tide, beaches are reduced to limestone rocks and seashell areas whereas during mid to low tide, wide stretches of white sand are available; shorebirds use the white sand and the limestone areas for feeding.

Gopher tortoises, raccoons, and armadillos are relatively plentiful in the sandy woodland areas near the roadside and the northeast side of the island.

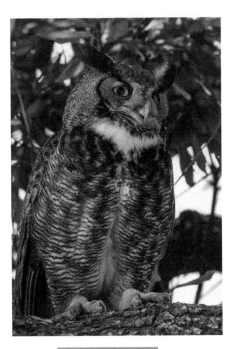

Great Horned Owl on perch overlooking the trail

HOTSPOT #1

MAP 1

CALADESI ISLAND STATE PARK:

MAP 1

Caladesi Island State Park, located south of Honeymoon Island, is only accessible by boat or ferry. There is a ferry service that runs from Honeymoon to Caladesi, the cost is $16 for individuals and $8 for children 6-12; children 5 and younger are free but still require a ticket to board the ferry. Ferry rides begin at 10 am and every thirty minutes thereafter, weather permitting.

Similar wading and shorebirds are found on Caladesi; however, there are fewer people than on Honeymoon Island.

📷 Site Specific Photography Tips

The park is open from 8 am till dark; this makes an early morning photography session nearly impossible. Photography in the pine forest will be good until roughly 10 am unless it is overcast. Late afternoons will provide many shorebird photographic opportunities with good light.

A telephoto lens from 400-600mm will be effective for the shorebirds. Get low to the ground and wait patiently, usually one will scamper by every few minutes. I like photographing the shorebirds on the moss-covered limestone rocks during high tide. Lots of beaches in Florida have white sand but few have these rocks with green moss or algae.

Migrating and overwintering birds, such as warblers, are typically small. Longer lenses are useful; a 600mm with a 1.4x teleconverter would be ideal. I like to park, in a legal parking area, near the shrubs and trees. I use my vehicle as a photography blind, and I can get nice images of the small birds in the foliage. At times, a flash with a flash extender is useful.

Gopher Tortoises are easily photographed with moderate telephotos. I use a ground pod and lie on my belly. If you move slowly, generally tortoises will continue feeding on grasses and forbs, totally ignoring your presence.

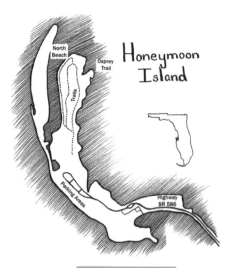

Honeymoon Island

North Beach
Osprey Trail
Trails
Parking Areas
Highway SR 586

HOTSPOT #1

Fort De Soto Park-North Beach, Tierra Verde, FL (Pinellas County)

MAP 1

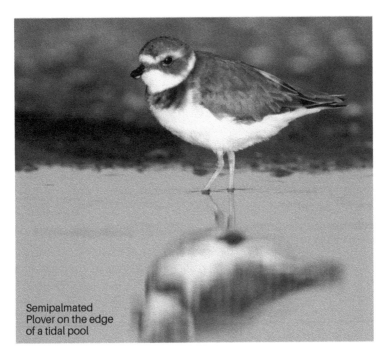

Semipalmated Plover on the edge of a tidal pool

Site Specifics:

Fort De Soto Park, 3500 Pinellas Bayway South, Tierra Verde, FL. Telephone: 727-582-2100. Website: https://www.pinellascounty.org/park/05_ft_desoto.htm

North Beach: Pinellas Bayway South dead ends in the park, turn right onto Anderson Boulevard at the flagpole and park headquarters building, and proceed approximately 0.5 miles, to the end. Park in the parking areas to the left, this is North Beach.

Fees: Park entrance requires payment of a $5 parking fee. Toll booths, found near the approach to the park, also require payment of fees. Most Florida residents invest in a SunPass for the numerous road fees around the state; these are available at the Florida Welcome Center.

Hours: The park is open from 7 am to sunset. Fees and hours of operation were current at the time of publication but subject to change; check the website for updates.

MAP 1

DESCRIPTION:

Fort De Soto Park is a 1,136-acre county park that is part of the barrier islands on the west coast of Florida. Fort De Soto was a military fort used during the Spanish-American War at the turn of the 20th century. This historic fort is located a few blocks north of the headquarters near the fishing pier area.

I have divided Fort De Soto into two hotspots because of the park size and diverse nature. The park consists of five interconnected islands or keys. These are Madelaine, St. Jean, St. Christopher, Bonne Fortune, and Mullet Key. Mullet Key is the largest of the keys. Mullet Key is a seven-mile island shaped like a right angle with north beach at the end of the north leg, the fishing pier and fort at the apex, and east beach and the headquarters along the northeast leg.

NORTH BEACH:

North beach consists of a long shoreline and numerous tidal pools or lagoons. The shape and size of the tidal pools change with each passing storm. Shorebirds and wading birds are most common in the shallow tidal pools and gulls and terns are common on the sandy beaches and near the tidal pools.

Brown pelicans can sometimes be seen over the gulf waters, but pelicans are more common in other areas of the park (see hotspots #3 for other common locations). Wood Storks are relatively common on the grass area near the pavilion area.

Shorebirds, wading birds, gulls, and terns are common at north beach year around. Activity heats up during breeding season with an increase in abundance of wading birds and gulls, especially Roseate Spoonbills, Snowy and Great Egrets and Great Blue, Tricolored and Little Blue Herons.

Good opportunities for flight shots include Black Skimmers in the tidal pools and Great Egrets at the shoreline. Some shorebirds, such as American Oystercatchers, prefer the shoreline to the tidal pool areas. I tend to concentrate at the north end of north beach as there are fewer people.

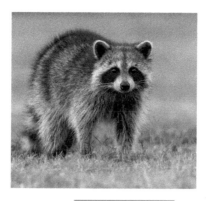

Raccoon in grass looking for a free meal

HOTSPOT #2

Occasionally, raccoons are digging in the shallow tidal pools at first light. Raccoons are also common in the pavilion area, in the palm trees, and at the forest edges. Grey squirrels are nearly everywhere but most common near the oak trees. Coyotes, yes coyotes, are now prevalent in Florida and can occasionally be seen, although seldom at north beach.

MAP 1

NORTH BEACH TRAIL:

There is a trail through the woodland that provides good opportunities for Great Horned Owls during the winter nesting season. Watch in the oaks and other trees for the relatively large nests. Also, watch along the ground for owl pellets (a bit smaller than a golf ball), a sure sign that there is a nest overhead.

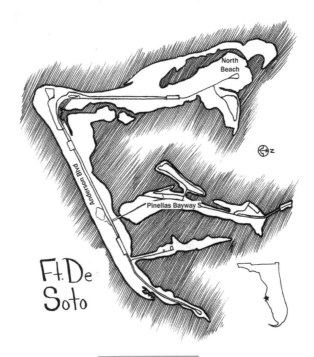

HOTSPOT #2

Fort De Soto Park-East Beach, Picnic Area and Approaches, Tierra Verde, FL (Pinellas County)

MAP 1

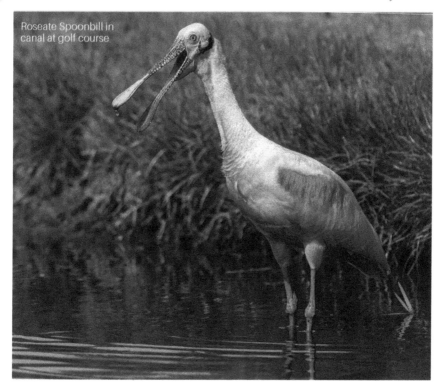

Roseate Spoonbill in canal at golf course

Site Specifics:

Fort De Soto Park, 3500 Pinellas Bayway South, Tierra Verde, FL (Pinellas County). Telephone: 727-582-2100. Website: https://www.pinellascounty.org/park/05_ft_desoto.htm

Fees: Park entrance requires payment of a $5 parking fee. Toll booths, found near the approach to the park, also require payment of fees. Most Florida residents invest in a SunPass for the numerous road fees around the state; these are available at the Florida Welcome Center.

Hours: The park is open from 7 am to sunset. Fees and hours of operation were current at the time of publication but subject to change; check the website for updates.

MAP 1

Isla Del Sol Yacht and Country Club: The Isla Del Sol Yacht and Country Club is located where SR 682 meets SR 679 (Pinellas Bayway South). From I-275 south, take exit 17 onto SR 682 that merges with Pinellas Bayway South; in 3.0 miles turn left on Pinellas Bayway South. The Country Club is located on both sides of Pinellas Bayway South.

Tierra Verde-West Shore Boulevard: West Shore Boulevard is 3.3 miles south of the intersection of SR 682 and SR 679.

Fort De Soto-East Beach: Follow GPS directions to the park entrance and proceed to the flagpole after paying fees at the entrance gate. At the flagpole and park headquarters, turn left on Anderson Boulevard and travel 1.3 miles to East Beach.

Fort De Soto-Picnic Area: Follow GPS directions to the park entrance and proceed to the flagpole after paying fees at the entrance gate. At the flagpole and park headquarters, turn right on Anderson Boulevard and travel 0.5 miles to the Picnic Area, on the right.

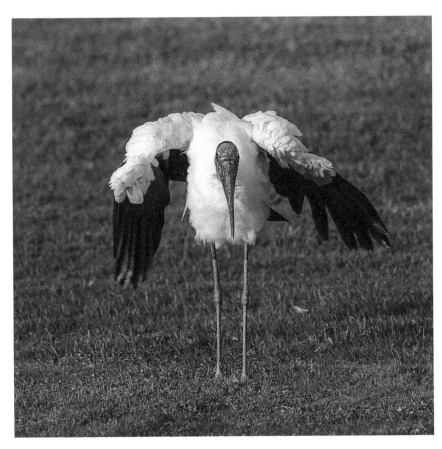

Wood Stork wing stretch

HOTSPOT #3

DESCRIPTION:

Isla Del Sol Yacht and Country Club: Adjacent to the corner of SR 682 and SR 679 is the golf course. At times, this is an excellent area for photographing Roseate Spoonbills. I typically see them either in the drainage ditch adjacent to SR 679 or on the grass. Anytime I am headed to or from Fort De Soto, I watch this area to see if they are present. If so, I park on the side of the road and photograph them from the roadside. The Yacht and Country Club is private property, so we are not allowed on the golf course.

Tierra Verde-West Shore Boulevard: Ducks, Great Egrets, and Wood Storks are common at the lake to the east of West Shore Blvd. This is a private deed-restricted community, so I would check with the guard shack at the entrance for parking and permission to photograph near the roadside and along the roadway.

Fort De Soto-East Beach: East Beach is a popular location for sunrise images of the Sunshine Skyway Bridge. Excellent images of wading birds, shorebirds, and pelicans are also possible. No formal parking exists but roadside parking is permitted.

Fort De Soto-Picnic Area: The picnic area is an excellent area for photographing raccoons and grey squirrels. Raccoons are abundant in this area because of the prospect of free food and squirrels love the abundant acorns from the surrounding oak trees. Pelicans and egrets are common near the water's edge. Abundant parking is available.

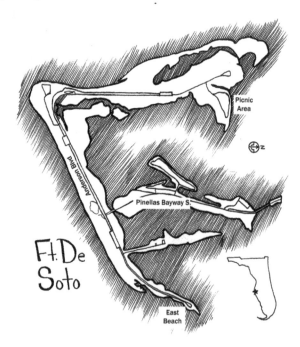

MAP 1

HOTSPOT #3

Sawgrass Lake Park, St. Petersburg, FL
(Pinellas County)

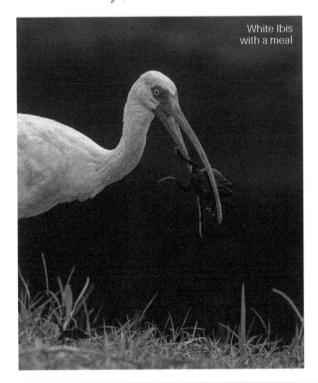
White Ibis with a meal

Site Specifics:

Sawgrass Lake Park, 7400 25th Street North, St. Petersburg, Florida. Telephone: 727-582-2100. Website: https://www.pinellascounty.org/park/16_sawgrass.htm

Directions: From I-275 (north) take exit 26B (54th Avenue North); I-275 (south) take exit 26 (54th Avenue North); head west, proceed 0.6 miles to Haines Road and turn right; in 0.2 miles turn right on 28th Street North. Proceed 0.3 miles and turn right on 62nd Avenue North, travel east 0.2 miles, and turn left on 25th Street North. The park is 0.8 miles at end of the road.

Fees and Hours: There is no fee for entry. The park is open from 8 am to near sunset. Fees and hours of operation were current at the time of publication but subject to change; check the website for updates.

MAP 1

DESCRIPTION:

Sawgrass Lake Park is a 400-acre county park consisting of two lakes, a borrow pit, and connecting streams with numerous boardwalks. The abundance of wildlife is surprising as the park is adjacent to a major interstate (I-275).

Numerous wading birds, such as herons, egrets, ibis, spoonbills, and Wood Storks can be found in the streams and shore areas of the lakes and connecting streams. Thousands of migrating birds stop at the park during spring and autumn attracting many birders and photographers.

Alligator sightings are not rare in the streams near the walkways. Gopher tortoises are relatively plentiful in the sandy woodland west and northwest of the borrow pit.

Occupied bat houses are near the roadway to the west of the borrow pit and a butterfly garden is north of Arrow Lake near the northeast boardwalk entrance. Rabbits are a common sight near the pavilion and bathroom structure.

SEASONALITY:

Wading birds are abundant year-round with peak activity in the mornings and evenings, especially during the hot summer months. Spring migration occurs March through May and autumn migration occurs September through November. Many of the migrating birds will use the boardwalk areas near the Maple Swamp and Oak Hammock.

Alligators and gopher tortoises are active during the daytime. During late autumn, winter, and early spring months, they can be seen any time of the day; during the summer they tend to be a bit more sedentary during the heat of the day and more active in the morning and late afternoon.

Bats are nocturnal so will be most active after dark although they can be seen leaving the nest boxes at dusk. Rabbits are most active at first light and just before dusk. Keep a sharp eye open for owls and bobcats; both are possible sightings in this park.

Gopher
Tortoise
walking in
grass

HOTSPOT #4

○ Site Specific Photography Tips

The land approach to the streams is gradual, making it possible to photograph the wading birds from near the waters' edge; however, keep a keen eye for alligators. Telephoto lenses of 300-400mm are usually sufficient for frame-filling images. Migrating birds are typically small and longer lenses are useful; a 600mm with 1.4x teleconverter would be ideal. Because of the tree canopy, a flash with a flash extender would be helpful.

Gopher Tortoises are easily photographed with moderate telephotos; remember to get very low or lie on the ground for the best images. If you move very slowly, generally tortoises will continue feeding on grasses and forbs, totally ignoring your presence.

MAP 1

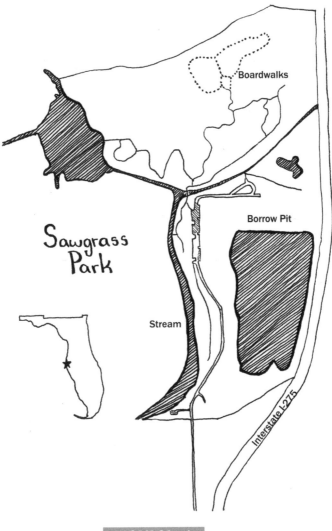

Boardwalks

Borrow Pit

Sawgrass Park

Stream

Interstate I-275

Cockroach Bay, Ruskin, FL
(Hillsborough County)

Site Specifics:

Cockroach Bay Nature Preserve and State Park, 3839 Gulf City Road, Ruskin, Florida. Telephone: 813-671-7754 (Preserve) and 941-723-4536 (State Park). Websites: https://www.hillsboroughcounty.org/en/loca-tions/cockroach-bay-preserve and https://www.floridastateparks.org/parks-and-trails/cockroach-bay-preserve-state-park

Fees: Entrance into the preserve and boat ramp area is free. Limited parking is available at both places. No facilities, such as bathrooms or concessions, are available so plan accordingly. No mosquitoes were present in the winter, but I would prepare for an onslaught during the warmer months.

Hours: The preserve is open from sunrise to sunset. Fees and hours of operation were current at the time of publication but subject to change; check the website for updates.

Directions: From I-75 (north or south), take exit 240B (FL 674-College Avenue) toward Ruskin, travel 3.2 miles to US 41-South Tamiami Trail, turn left. Travel 3.1 miles and turn right on Cockroach Bay Road. Continue 1.8 miles to Gulf City Road. The nature preserve is one block to the north on Gulf City Road and the boat ramp is at the end of Cockroach Bay Road.

DESCRIPTION:

With a name like Cockroach Bay, you would not expect a plethora of people to visit the area; you would be correct. However, the name Cockroach Bay is believed to stem from the abundant horseshoe crabs that once used the mangrove-covered islands for nesting and mating. The horseshoe crabs were once so numerous on the west coast of Florida that Spanish explorers called them cockroaches.

Cockroach Bay is located near the entrance to Little Manatee River and the state park consists of 617 acres of assorted islands and a mangrove swamp. Most of the park is only accessible via boat (kayak, canoe, flat bottom, or fiberglass boat) however the state preserve and two hiking trails are located on the mainland.

Nature Preserve: The preserve entrance is located one block north of Cockroach Bay Road on Gulf City Road. There is a small parking area and two hiking trails. One trail climbs a small hill, Cockroach Mountain, overlooking the mangroves and swamp; the second trail winds through the mangroves and deep into the brush. Both are maintained.

MAP 1

MAP 1

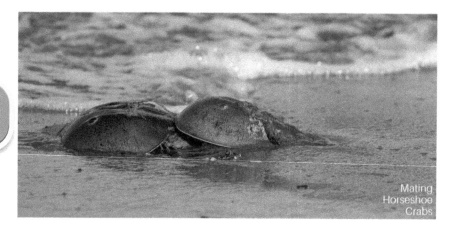

Mating
Horseshoe
Crabs

Aquatic Trails: The Snook Canoe Trail winds through the mangroves to the north of the boat ramp and the Horseshoe Crab Canoe Trail winds through the mangroves to the south. Both are excellent trails, accessible by small boats such as kayaks and canoes, for winding through the protected backwaters of the islands.

Numerous Ospreys were observed on telephone poles and a few Red-tailed Hawks were seen on the power lines. Little Blue Herons, Great Egrets, and Brown Pelicans were seen at the boat ramp. Overwintering birds were numerous in the mangroves, oaks, and palms. It is hard to believe, but few noises of the surrounding city were heard above the melodious music of the many birds in the brush.

Overwintering birds include Painted and Indigo Buntings, Ruby-crowned Kinglet, warblers (Black and White Warbler, Northern Waterthrush and Ovenbird), sparrows (Savannah, Field, and White-crowned) in addition to the Scissor-tailed Flycatcher and the Eastern Phoebe.

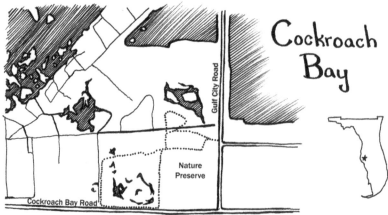

Cockroach Bay

Gulf City Road

Nature Preserve

Cockroach Bay Road

Boat Ramp & Aquatic Trails

HOTSPOT #5

Hillsborough River State Park, Tampa, FL (Hillsborough County)

MAP 1

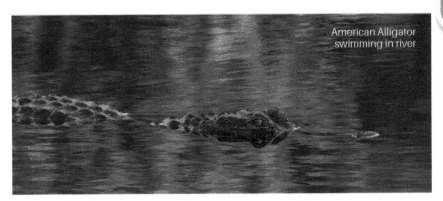

American Alligator swimming in river

Site Specifics:

Hillsborough River State Park, 15402 US 301 North, Thonotosassa, FL. Telephone: 813-987-6771. Website: https://www.floridastateparks.org/parks-and-trails/hillsborough-river-state-park

Fees: Park entrance requires payment of a fee that depends on the number of occupants in your vehicle. Entrance fees for one person per vehicle are $4, two to eight persons in a single vehicle are $8 and pedestrians or bicyclists are $2. An annual state parks pass is available for Florida Parks; it is an excellent value if you plan many visits to the state parks.

Hours: The park is open from 8 am to sunset, 365 days per year. Fees and hours of operation were current at the time of publication but subject to change; check the website for updates.

DESCRIPTION:

Hillsborough River State Park is a 2,990-acre state park located near the northeast corner of Hillsborough County. The Hillsborough River, a class 2 rapid, courses through the park. Seven miles of hiking trails wind through various forest types.

The Hillsborough River runs roughly east-west through the park. The Rapids Trail (1.2 miles) follows part of the south bank of the river whereas the Baynard Trail (1.1 miles) and the Seminole Trail (3.2 miles) are on the north side of the river. The Wetlands Restoration Trail (1.6 miles) passes through pine flatwoods and leads to the Fort King Trail (2.2 miles).

MAP 1

With a variety of habitats (pine flatwoods, cypress swamp, grass ponds, hardwood, and hydric hammock), wildlife abounds. Wildlife at the park ranges from river otters, alligators, turtles, raccoons, rabbits, deer, in addition to fox and flying squirrels, and birds.

An abundance of birds occupies the park year-round. Barred Owls, Nighthawks, Loggerhead Shrikes, Woodcocks and Bobwhites, Downy and Red-bellied Woodpeckers, Night and Green Herons are common. In winter, migrants such as Common Yellowthroat, Black and White Warbler, Pine, and Palm warblers are popular. Despite the variety of wildlife, the real gem of this park is the variety of landscape and woodland photography.

Much of the forest is old-growth oaks and hardwoods. Some of these older trees have amazing character. Also, beautiful images await the photographer along the river as the forest canopy extends over the riverbank.

HOTSPOT #6

📷 Site Specific Photography Tips

Long telephoto lenses will be best for the wildlife whereas wide-angle lenses will be best for the woodlands and landscapes.

The best weather for woodland photography is misty or foggy mornings. The park is open from 8 am to sundown, this makes it a bit difficult to catch foggy mornings unless the fog lingers a bit into the late morning hours.

Light to heavy overcast is favored for river photography to reduce the specular highlights. A polarizer will help accentuate the colors and reduce some of the reflections. When photographing the rapids, a neutral density filter will help slow your shutter speeds to produce the silky-smooth water so desired by many photographers.

Both a moderate wide-angle lens, such as 24-105mm, and a super-wide, such as 16-35mm, will be useful. A tripod with a ball-head will increase your keeper rate. All of this equipment, with a snack and bottle of water, can be carried in a small backpack.

MAP 1

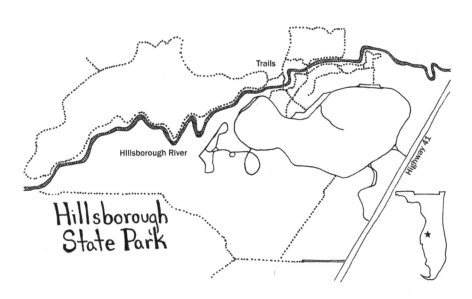

Trails

Hillsborough River

Highway 41

Hillsborough
State Park

Venice Rookery, Venice, FL
(Sarasota County)

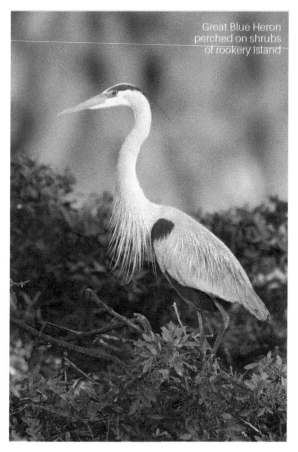

Great Blue Heron perched on shrubs of rookery island

Site Specifics:

Venice Area Audubon Rookery, Annex Road, Venice, Florida. Telephone: 941-496-8984. Website: https://www.veniceaudubon.org/rookery

Fees: There is no fee for entry but there is a donation box adjacent to the pavilion; donations benefit the Venice Area Audubon Society that oversees the park operations.

Hours: The rookery is open 24 hours a day, 7 days a week. Fees and hours of operation were current at the time of publication but subject to change; check the website for updates.

DESCRIPTION:

Venice Rookery is one of the premier wildlife locations, not only in Florida but in the United States. A small scrub-covered island in the middle of a former storm-retention pond provides nesting habitat for Great Blue Herons, Great Egrets, and Anhinga. Other wading birds, such as Green, Little Blue, and Tri-colored Herons, Black-crowned Night Herons, Cattle and Snowy Egrets, Double-crested Cormorants, and Glossy Ibises occasionally nest on the island. White Ibises and a few other birds roost on the island and typically leave at first light. Because the island is relatively close to the mainland, it provides an excellent place to view and photograph the birds.

Raptors are occasionally seen in the snags and alligators are occasionally sighted in the water near the island; grey squirrels are abundant on the mainland. A butterfly garden is located near the Venice Audubon Center just north of the rookery. Bat houses are located south of the rookery on the mainland.

Seasonality: Because of the tropical nature of Florida, birds roost on the island throughout the year. However, the breeding season is the prime time to visit the rookery. Great Blues breed from November through May, Great Egrets breed from January to early summer, and Anhinga breed in spring (March-June).

MAP 1

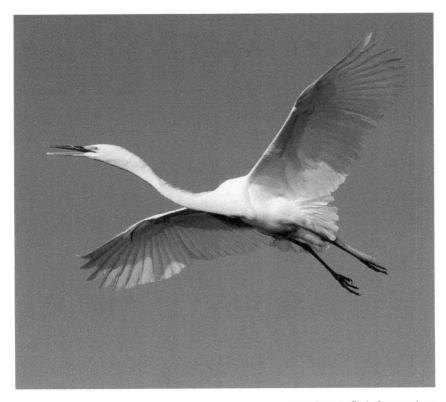

Great Egret in flight from rookery

MAP 1

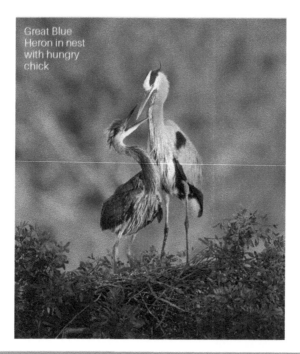

Great Blue
Heron in nest
with hungry
chick

📷 Site Specific Photography Tips

Most photographers prefer to photograph in the early morning as the sun rises from the east illuminating the rookery to the west. Lenses of 500-600 mm will be best for images of roosting and nesting birds on the island. A 1.4X teleconverter will be helpful for the smaller herons or egrets. Lenses of 200-400mm will work well for flight shots.

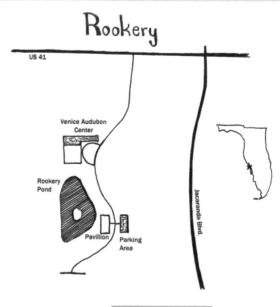

Rookery

US 41

Venice Audubon Center

Rookery Pond

Pavillion Parking Area

Jacaranda Blvd.

Circle B Bar Reserve, Lakeland, FL (Polk County)

MAP 1

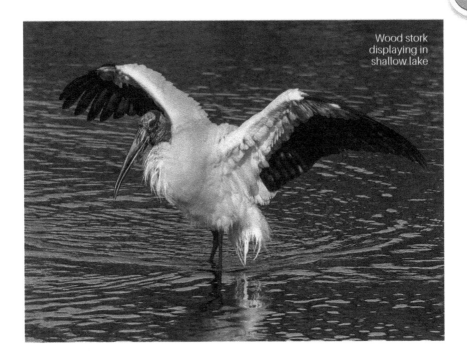

Wood stork displaying in shallow lake

Site Specifics:

Circle B Bar Reserve, 4399 Winter Lake Road, Lakeland, Florida. Telephone: 863-668-4673. Website: https://polknature.com/explore/circle-b-bar-reserve

Fees and Hours: There is no fee for entry to the reserve and the area is very well maintained. The reserve is open 6 am to 6:30 pm. Fees and hours of operation were current at the time of publication but subject to change; check the website for updates.

Directions: From the entry gate, proceed along the road to the central parking areas. There are four parking areas, and the trails are accessed from these parking areas. The Discovery Center is centrally located and is an excellent place to obtain a map and start your adventure.

DESCRIPTION:

Circle B is one of the premier wildlife locations; it is a former cattle ranch that is undergoing restoration back to its natural state as marsh and wetland habitat adjacent to Lake Hancock. The wilderness area consists of 1,267 acres and a trail system is designed as an east-west oriented figure eight.

The gate opens about an hour before sunrise and closes about an hour after sunset. This is excellent for photographers that desire to photograph the animals and landscape during the golden hours of the day.

Bathrooms are in the Discovery Center and there are also portable bath facilities near the Shady Oak Trail. There is ample parking for cars. If you arrive early, you can snag a couple of parking spaces for your larger rigs. Off-road and roadside parking is not allowed.

Although the trails are interconnected, they transverse different habitats and have different names. The southern trails follow the Banana Creek marsh and canal. These trails are Wading Bird Way (0.7 miles), Heron Hideout (0.3 miles), Marsh Rabbit Run (0.7 miles), Longleaf Lane (0.8 miles), and portions of Eagle Roost (0.7 miles) and Alligator Alley (1.2 miles). Much of the Eagle Roost trail transverses upland sandy habitat and part of the Alligator Alley trail is adjacent to Lake Hancock.

Most of the northern trails transverse oak hammocks. These trails are Windmill Whisper (0.4 miles), Treefrog Trail (0.6 miles), Acorn Pass (0.2 miles), Shady Oak (0.7 miles), and Lake Trek (0.5 miles). Long Bridge Trail (0.7 miles) begins in the oak canopy and continues along a boardwalk over the swamp.

Wading birds, such as herons, ibises, Roseate Spoonbills, Wood Storks, egrets, Common Moorhens, Sandhill Cranes, Osprey, and Limpkin are common along the southern trails adjacent to the marsh and lake. Woodpeckers and some passerines (such as Painted Buntings) are common in the snags and trees. Raccoons, otters, turtles, alligators, and Marsh Rabbits are a common occurrence.

Bald Eagles nest along the sandy portion of the Eagle Roost trail. Meadowlarks, American Kestrels, Osprey, vultures, and Bobwhites are occasionally seen. Gopher Tortoises have numerous burrows along this stretch.

The northern trails are home to raccoons, rabbits, armadillo, and the occasional fox. Birds include Great Horned and Barred Owls, Bald Eagles, American Kestrels, Red-shouldered Hawk, and numerous migrants (during migration).

An abundance of old-growth oak trees is available providing many opportunities for woodland and landscape photography. Some of the trails are oriented north-south providing excellent opportunities for sunrise or sunset images.

MAP 1

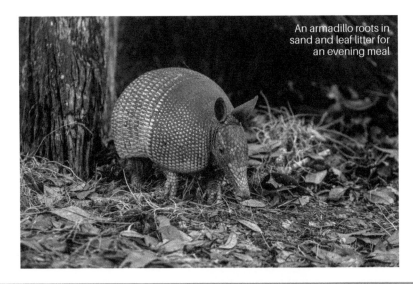
An armadillo roots in sand and leaf litter for an evening meal

MAP 1

📷 Site Specific Photography Tips

Most of the trails are oriented either east-west or north-south. The north-south trails are ideal for wildlife photography. The mammals and birds seem very habituated to human presence; moderate to long telephoto lenses will be ideal for capturing many excellent wildlife images.

Remember, when possible, shoot at the animal eye-level. When photographing small mammals and small water birds, getting low to the ground will provide a more intimate image. The shoreline of the marsh has a very gradual decline making such images possible, but always watch for alligators.

The eagle nests along Eagle Roost are distant from the trail, even a 600mm lens will not provide good frame-filling images. However, flight shots are possible as the eagles leave and return to the nests with food for the growing chicks.

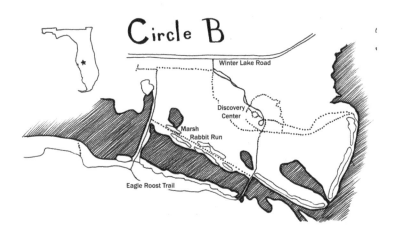

Circle B

Winter Lake Road

Discovery Center

Marsh
Rabbit Run

Eagle Roost Trail

HOTSPOT #8

Oscar Scherer State Park, Osprey, FL (Sarasota County)

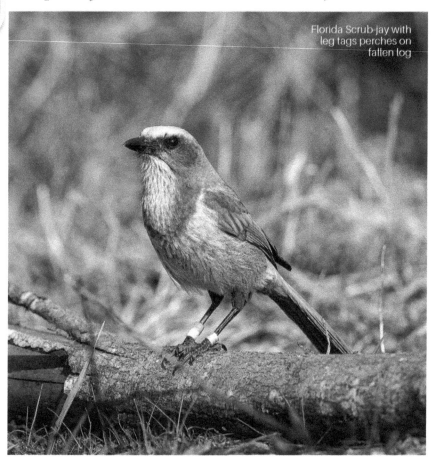

Florida Scrub-jay with leg tags perches on fallen log

Site Specifics:

Oscar Scherer State Park, 1843 South Tamiami Trail, Osprey, FL. Telephone: 941-483-5956. Website: https://www.floridastateparks.org/parks-and-trails/oscar-scherer-state-park

Fees: Park entrance requires payment of a fee that depends on the number of occupants in your vehicle. Entrance fees are $5 per vehicle (up to five persons) and $2 per extra person; pedestrians or bicyclists are $2. An annual state parks pass is available for Florida Parks; it is an excellent value if you plan many visits to the state parks.

MAP 1

Hours: The park is open from 8 am to sunset, 365 days per year. Fees and hours of operation were current at the time of publication but subject to change; check the website for updates.

Directions: Upon entering the park, proceed along the main road; the campground is about half a mile on the right; parking and picnic areas are scattered along the main road. The main road ends at Lake Osprey and the Nature Center.

DESCRIPTION:

The 1,392-acre park consists of mostly scrubby flatwoods, palmettos, and sandy soil, ideal habitat for the endemic Florida Scrub-jay (found only in Florida) and the threatened Gopher Tortoise. The park is divided into multiple trails covering 15 miles.

The longer trails include the Yellow, Blue, Red, Green, and Legacy trails (5 miles, 1.5 miles, 1.5-2 miles, 2-3 miles, and 10 miles, respectively). Shorter trails, ranging from ¼ mile to ¾ mile, include the Orange, Lester Finley, South Creek, Legacy Honore Trail Connection, Lake Osprey, and Florida Scrub-jay Trails.

The Blue and Green Trails are best for spotting the Scrub-jays. The Scrub-jays nest along the Green Trail, as do Bald Eagles. The Florida Scrub-jay Trail, a self-guided trail through Scrub-jay habitat, is not a separate trail, it is portions of the Red, Blue, and Yellow Trails.

The Lester Finley Trail is a barrier-free trail designed for those of all abilities, including those with sight, mobility, and hearing impairments. This trail includes butterfly gardens and a fishing dock.

Park activities, in addition to bird watching and photography, include bicycling, camping, swimming (in Lake Osprey), fishing, and canoeing. Canoes are available for rental.

Numerous birds are common to the park, in addition to the Florida Scrub-jay. These include the Gray Catbird, Northern Mockingbird, Eastern Towhee, Northern Cardinal, Red-winged Blackbird, Blue Jay, Red and White-eyed Vireo, Fish Crow, Carolina Wren, Blue-gray Gnatcatcher, Common Ground Dove, Black and Turkey Vultures, Bald Eagle, Red-shouldered Hawk, Osprey, Laughing Gull, Great Blue and Little Blue Herons, Great Egret, Wood Stork, Mottled Duck, Anhinga and Double-crested Cormorant. Migrants are common during spring and fall.

In addition to birds, numerous grey squirrels, a few alligators, and the occasional raccoon are common residents of the park.

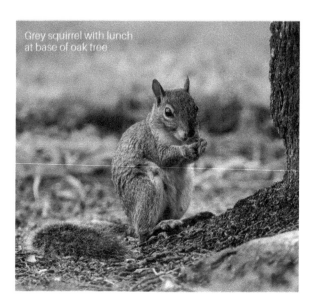

Grey squirrel with lunch at base of oak tree

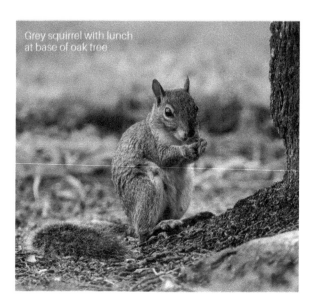

MAP 1

📷 Site Specific Photography Tips

Small birds, like the Scrub-jay, are typically best photographed with long lenses such as 500 or 600mm. Larger birds, such as the wading birds, can be photographed with moderate to long telephoto lenses.

Gopher Tortoises are fairly habituated and can be photographed with a 100-400mm lens. I like to get down on the ground for eye-level images of the tortoises.

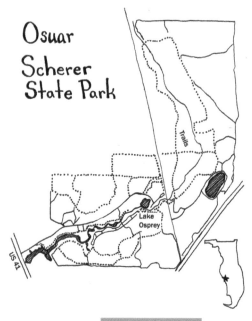

Osuar Scherer State Park

Trails

Lake Osprey

US 41

HOTSPOT #9

Myakka River State Park, Sarasota, FL (Sarasota County)

MAP 1

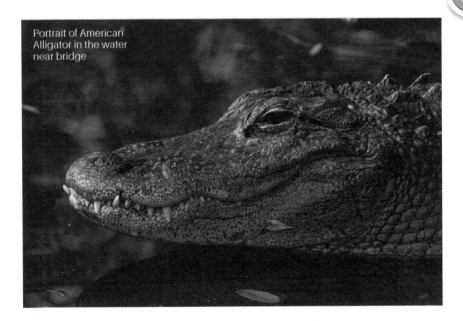

Portrait of American Alligator in the water near bridge

Site Specifics:

Myakka River State Park, 13208 State Road 72, Sarasota, FL. Telephone: 941-361-6511. Website: https://www.floridastateparks.org/parks-and-trails/myakka-river-state-park

Fees: Park entrance requires payment of a fee that depends on the number of occupants in your vehicle. Entrance fees for one person per vehicle are $4, two to eight persons in a single vehicle are $6 and pedestrians or bicyclists are $2. An annual state parks pass is available for Florida Parks; it is an excellent value if you plan many visits to the state parks.

Hours: Park hours are 8 am to sundown, unless you are a registered camper within the park. The primary entrance is the south entrance on SR 72; the north entrance is only open on weekends and state holidays from 8 am – 5 pm. Fees and hours of operation were current at the time of publication but subject to change; check the website for updates.

DESCRIPTION:

MAP 1

Myakka River State Park consists of 58 square-miles of wetlands, pine forests, hammocks, prairies, a river, and two shallow lakes. Access to the park interior is available via a network of hiking trails and service roads.

Boat and tram tours are available for purchase. There is a boat ramp at the upper lake; canoes, kayaks and bicycles are available to rent if you do not bring your own. Traditional campsites are available as well as primitive campsites.

Numerous birds are abundant in the park; some are permanent residents and others are winter or summer residents. Transients are also seen occasionally. A bird list is available at the ranger station.

Alligators are relatively abundant, as are Gopher Tortoises. White-tail deer are also abundant in the forest. Wild boars inhabit the park, but the park has a regular trapping program to remove them. Large cage traps are frequently seen in forest areas. Many smaller mammals, such as squirrels and raccoons are also abundant.

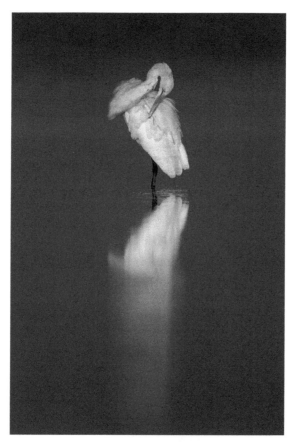

Great Egret preening in shallow water

HOTSPOT #10

📷 Site Specific Photography Tips

The park ranges from bright sunshine in open prairie areas to darker areas in the closed canopies. Typically, the best times for wildlife photography in Florida are early mornings and late afternoons. Because the park is not open till 8 am, early mornings are difficult unless you are camping within the park.

I keep my lenses on the passenger seat as I am driving the North Road, always ready to get a photograph when I see an animal. At times, I will keep my bean bag on the window opening. I preset my exposures so my camera is always ready for the shot; no need to fumble with exposure settings when you come upon an animal as they will not wait for you to fumble.

MAP 1

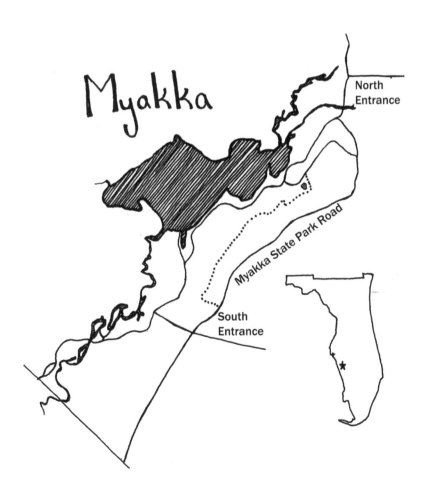

Pelicans at Placida, Placida, FL (Charlotte County)

MAP 1

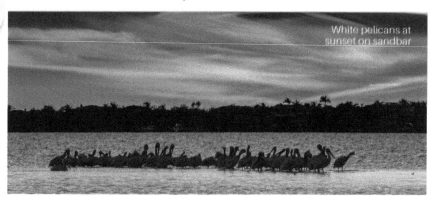

White pelicans at sunset on sandbar

Site Specifics:

Placida Fishing Pier, Gasparilla Road at Fishery Road, Placida, FL, and Gasparilla Boat Tours, 15001 Gasparilla Road, Placida, FL

Brown Pelicans are in the area year-round, but the White Pelicans are only winter residents. Many of the White Pelicans spend the summers in the Rocky Mountain area, such as Jackson Lake in the Tetons of Wyoming.

Fees and Hours: There are no parking fees or specific hours at the marina or the fishing pier. Fees and hours of operation were current at the time of publication but subject to change; check the website for updates.

DESCRIPTION:

Pelicans are usually abundant in the area near the fishing pier. This is part of Gasparilla Sound and Coral Creek. The pelicans respond well to baitfish which can be purchased from the nearby bait houses.

The "go-to" charter boat for trips to Audubon Island was Captain Marian Schneider; however, she retired and closed her boat charter business in 2013. There are a few other charter businesses located in the marina area. I spoke with the folks at Gasparilla Boat Tours and Captain Tim will do private boat charters to the pelicans. Because of the cost of the charter, it would be good to have a few other photographers along to help offset the fees.

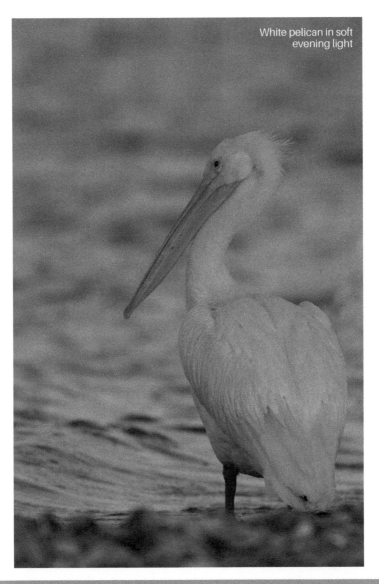
White pelican in soft evening light

MAP 1

📷 Site Specific Photography Tips

Because of the massive size of the White Pelicans, moderate telephoto lenses are usually sufficient from the fishing pier and shoreline of Gasparilla Sound. At times, the pelicans will venture out into the sound and longer lenses are useful.

Photography from a boat can be challenging, especially the first time you attempt it. Pontoon boats, on a calm day, are much more stable than V-bottom boats. My preference is to handhold my camera as tripods transmit all the movement of the boat to the equipment. This is usually not a problem as most days are Sunny 16 in Florida. As it approaches sunset, just up the ISO to keep shutter speeds high enough for handholding.

HOTSPOT #11

Cape Coral Burrowing Owls, Cape Coral, FL (Lee County)

MAP 1

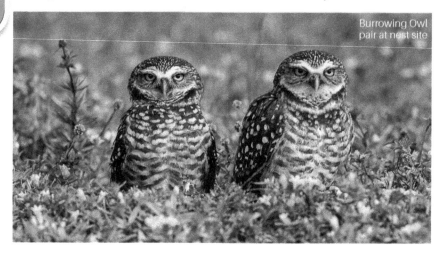

Burrowing Owl pair at nest site

Cape Coral has the largest concentration of Florida Burrowing Owls in the world. There are numerous areas with owl nests, but my favorite is the Cape Coral-Lee County Public Library.

Site Specifics:

The five areas are within a five-mile radius of each other; however, because of human population density, it will take a few minutes to travel to each site. These are not the only areas in the city with burrowing owls, just some of the most popular and best advertised.

Cape Coral-Lee County Public Library, 921 SW 39th Terrace, Cape Coral, FL
There are lots of nest sites on library property and in the adjacent neighborhood on vacant pieces of property.

Saratoga Lake Park, 170 SE 4th Terrace, Cape Coral, FL
There is a roped area at northwest corner of the park with a few active nests; some natural pieces of wood have been added for perches.

Koza Saladino Park, 301 SW 30th Terrace, Cape Coral, FL
This park consists of a couple of baseball diamonds and a few nests surrounding the parking area.

Cape Coral City Hall, 1015 Cultural Park Boulevard, Cape Coral, FL
There are a couple of nests near Cultural Park Boulevard.

MAP 1

Veterans Park, 4140 Coronado Parkway, Cape Coral, FL

This is a small park with a pavilion and playground, a few nests were observed near the church parking area and in the neighborhood on vacant properties.

BMX Track, 1410 SW 6th Place, Cape Coral, FL

This was once a very popular location for the Burrowing Owls and Bald Eagles. However, during my visit this year, I only found two abandoned nests and did not see the Bald Eagle nests.

Fees and Hours: There are no entrance fees or parking fees for any of the sites listed above. There are no specific hours for each of these sites.

DESCRIPTION:

The library site had the most active nests. A few of the nests were located on the library property but most of the best sites were on vacant properties near the library. Burrowing Owls live and nest in burrows in the soft sand.

Nest sites are typically staked with PVC pipes. A few perches are included in each site. Florida Burrowing Owls are a protected species.

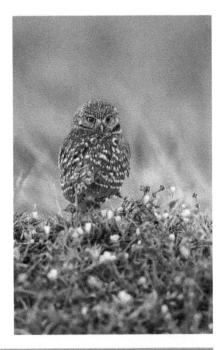

Burrowing Owl at nest

📷 Site Specific Photography Tips

Burrowing Owls can be photographed from your vehicle or at ground level. Typically, the best images are taken low to the ground because the owls are relatively small. Look for owls that are standing on a slightly raised mound for cleaner backgrounds.

Occasionally, owls will perch on the sticks and this can result in some nice images. The Saratoga Lake site had some natural sticks that are much more attractive than the man-made crosses.

When photographing a single owl, I use an aperture of f/6.1 or less and when photographing a pair of owls or an owl family, I will use a much smaller aperture, such as f/11.

Sanibel Island, Sanibel, FL (Lee County)

MAP 1

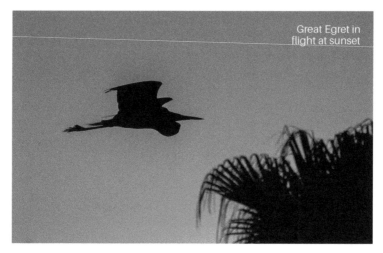

Great Egret in flight at sunset

Sanibel Island is a barrier island located on the west coast of Florida near Ft. Myers and Cape Coral. The island is approximately 3 miles wide and 12 miles long. Captiva Island, just to the north, is approximately 5 miles long and 0.5 miles wide. This area could easily be divided into multiple hotspots, or even fill its own guidebook. I have divided it into two hotspots. One hotspot will cover the island features and the second hotspot will cover Ding Darling National Wildlife Refuge.

Site Specifics:

Sanibel Causeway Beach, 19931 Sanibel Causeway Road, Sanibel Island, FL

Lighthouse Beach and Pier, 110/153 Periwinkle Way, Sanibel, FL

Bowman's Beach, 1700 Bowman's Beach Road, Sanibel, FL

Blindpass Beach, 6497 Sanibel-Captiva Road, Sanibel, FL

Fees: The toll to cross the Sanibel Causeway is $6 for a two-axle vehicle ($3 per additional axle). There are no parking fees for the causeway beaches. Public parking at any beach on Sanibel Island, lighthouse, or the pier will cost $5/hour.

Hours: There are no specific hours for each of these sites. Fees and hours of operation were current at the time of publication but subject to change; check the website for updates.

DESCRIPTION:

Although the above four sites are different, the wildlife are similar, as are the photographic tips. Therefore, these have all been grouped as a single hotspot. Expect to see a variety of wading birds, shorebirds, gulls and terns, pelicans, and Osprey at each of these four sites.

MAP 1

Sanibel Causeway Beaches:
The causeway crosses San Carlos Bay via a couple of bridges and small islands from the mainland to Sanibel Island. Beaches are located on each of these spoil islands. The causeway is oriented roughly northeast to southwest. The beaches attract many shorebirds and wading birds. Lots of pelicans, gulls, and terns are seen flying as you cross the bridges; however, foot traffic (or photographers) is not allowed on the bridges.

Lighthouse Beach and Pier:
The fishing pier, lighthouse, and the associated beach are located at the southern tip of Sanibel Island. Wading birds and pelicans are attracted to this area. Some of the fishermen feed scraps to the birds so the birds are a bit habituated. Some excellent flight shots are possible at this location, especially from the elevated pier.

If you have a cast net, use it under the pier to acquire some tiny fish, add these to a bucket and egrets will come to the bucket to feed. This permits excellent opportunities to photograph these birds closely and while handling their tiny catch. I learned this tip from bird photographer Arthur Morris.

Bowman's Beach:
This beach is located at the northwest shore of the island. It is one of the premier white sand beaches in the world and attracts wading birds, shorebirds, gulls, terns, and other water birds. Because it is located on the northwest shore, it is excellent for morning bird photography with the sun at your back or sunset photography with the sun over the ocean.

Blindpass Beach:
This beach is located at the northern tip of the island near Blindpass inlet between Sanibel and Captiva. Similar to the other locations, it is excellent for wading birds, shorebirds, gulls, terns, and other water birds.

Sanibel-Captiva Conservation Foundation (SCCF):
The SCCF is the largest private landowner on Sanibel Island and maintains over 8 miles of hiking trails. These include the SCCF Nature Center trail, Periwinkle Preserve, Bob Wigley Preserve, and Bailey Homestead Preserve including the Shipley Trail. If interested, inquire at the Sanibel Island Welcome Center for a trail map and information.

HOTSPOT #13 37

MAP 1

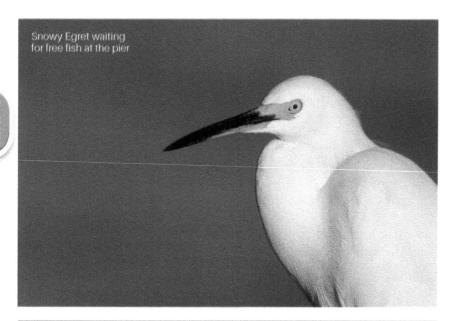

Snowy Egret waiting
for free fish at the pier

📷 Site Specific Photography Tips

Except for the parking fees and tolls, there is little not to like about Sanibel Island. You have a choice of many locations and light angles. Wading birds, shorebirds, gulls, terns, and pelicans abound. Moderate to long telephoto lenses will be best for recording individual birds. Short telephoto to moderate wide angle lenses can be used for landscapes and birdscapes.

Most of the parks in Florida do not open before sunrise and close at sunset. However, because there are no gates that limit access to the Sanibel public beaches, it is possible to arrive well before sunrise and stay well after sunset. However, make sure to pay the parking fees and display the parking permits in your vehicle.

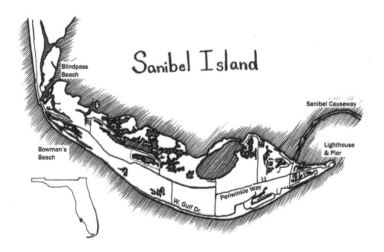

Sanibel Island

Blindpass Beach

Sanibel Causeway

Bowman's Beach

Lighthouse & Pier

W. Gulf Dr.

Periwinkle Way

HOTSPOT #13

Ding Darling National Wildlife Refuge, Sanibel, FL (Lee County)

MAP 1

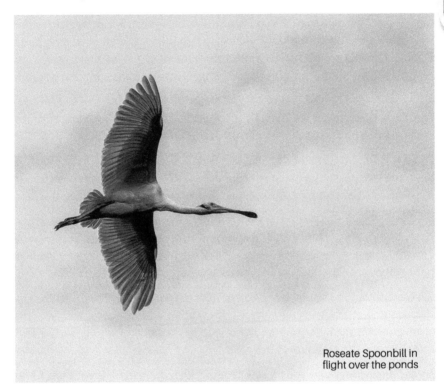

Roseate Spoonbill in flight over the ponds

Ding Darling National Wildlife Refuge is located on the eastern side of Sanibel Island. Sanibel Island is a barrier island located on the west coast of Florida near Ft. Myers and Cape Coral.

Site Specifics:

J. N. "Ding" Darling National Wildlife Refuge, 1 Wildlife Drive, Sanibel, FL. Website: https://www.fws.gov/dingdarling/VisitorInformation.html

Fees: The toll to cross the Sanibel Causeway is $6 for a two-axle vehicle ($3 per additional axle). The entrance fee for the refuge is $10 for vehicles and $1 for bicycles and hikers. National Park Pass holders enter for free.

Hours: The park gate opens at 7 am and closes at 5:30 pm. The park is closed on Fridays. Fees and hours of operation were current at the time of publication but subject to change; check the website for updates.

DESCRIPTION:

The refuge consists of a four-mile one-way road known as Wildlife Drive that winds through the mangroves with many open areas consisting of small lagoons and shallow pools. The shallow pools are teeming with wading birds, shorebirds, and occasionally White Pelicans.

As you enter the gate from the south, a couple of lagoons are immediate to the left. These are usually excellent for Roseate Spoonbills and other wading birds. Parking is only permitted on the right side of the road. A few other lagoons are on the left and right sides of the road between the entrance and the observation tower.

The observation tower area consists of much larger lagoons with lots of shorebirds, wading birds, and White Pelicans (during the winter months).

Three walking trails are located within the refuge: Calusa Shell Mound, Wulfert Keys, and Indigo Trail. Calusa Shell Mound Trail includes interpretive signs about the Calusa Indians and the Wulfert Keys Trail provides open access to the Pine Island Sound.

The Indigo Trail is a 2-mile trail that begins at the visitor's center and ends at Cross Dike, near mile marker #2 of Wildlife Drive. This trail is excellent for wading birds, shorebirds, and smaller mammals such as raccoons and alligators.

Separated from the refuge is the Bailey Tract (off Tarpon Bay Road), a 100-acre freshwater wetland with numerous trails and an abundance of wildlife. This is an excellent area for avian migrants during the fall and spring. Turtles and alligators are also common in this area.

Larger birds commonly seen in the lagoons include herons (Great Blue, Little Blue, Tricolored, Reddish, and Yellow-crowned Night Heron), egrets (Snowy and Great), White Ibis, Wood Stork, Roseate Spoonbills, Brown Pelicans, Anhinga, and Double-crested Cormorants. Shorebirds commonly seen in the lagoons include Willet, Spotted Sandpipers, and Black-bellied Plovers. Osprey, Bald Eagles, vultures, and Red-shouldered Hawks are commonly seen in the snags and flying overhead.

Common seasonal birds include the White Pelican, Black-necked Stilt, Pied-billed Grebe and Red-breasted Merganser, Belted Kingfisher, and the Blue-winged Teal duck.

MAP 1

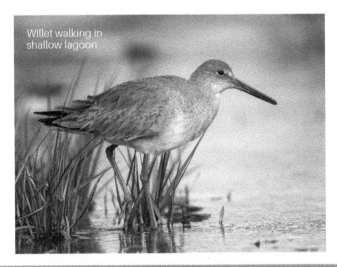

Willet walking in shallow lagoon

MAP 1

📷 Site Specific Photography Tips

Because the gates are not open until after sunrise and close before sunset, photography during the blue and golden hours is excluded. However, if you arrive when the gates first open, you will have many excellent opportunities for images of wading birds in the lagoons.

The Wildlife Drive is only four miles in length. I find the first 2/3 of the drive to be the most productive with the lagoons (near the entrance) and the observation tower very high on my list of hotspots. Long telephoto lenses, such as 500mm-600mm will yield excellent opportunities.

It is possible to shoot from the vehicle but as a courtesy to other drivers, it is better to park on the right and shoot from ground-level near the edge of the lagoons.

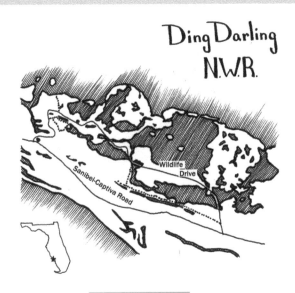

Ding Darling
N.W.R.

Wildlife Drive

Sanibel-Captiva Road

HOTSPOT #14

Little Estero Lagoon, Estero, FL (Lee County)

MAP 1

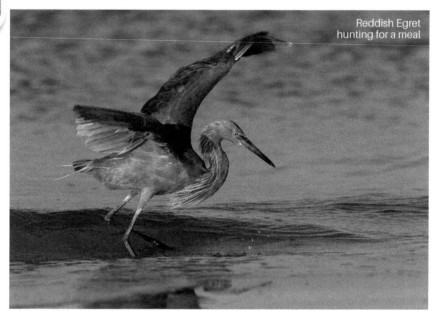
Reddish Egret hunting for a meal

Site Specifics:

Little Estero Lagoon, 7600-7980 Estero Boulevard, Estero, FL.

Fees and Hours: Little Estero Lagoon is open beach with no set hours and no set fees. However, few good options are available for parking as most of the area is private condos, private businesses, and other restricted areas.

I have parked in the CVS parking lot in the past, but it is a bit of a hike to the lagoon. For this reason, Little Estero is not high on my list of hotspots. If you have a partner, they can drop you off and then find a suitable parking area. The photography in this area can be awesome.

DESCRIPTION:

With each passing storm or hurricane, Little Estero Lagoon is reshaped and remodeled. Typically, there is a long shallow lagoon that runs parallel to the shoreline with nice white sand on both sides of the lagoon. However, some sections of the lagoon are deeper so exercise care.

Shorebirds, wading birds, gulls, and terns are common year-round. Winter and early spring are the best. Shorebirds tend to feed along the borders of these shallow lagoons. These shorebirds include Snowy, Wilson and Piping Plovers, Red Knots, American Oystercatchers, and Black Skimmers. Numerous gulls and terns also congregate near the lagoon borders.

Wading birds tend to feed in the shallow water area of the lagoons. These include Great Blue Herons and egrets (Reddish, Great and Snowy). Osprey, Double-crested Cormorants and Brown Pelicans are also common, typically near the shoreline of the gulf.

MAP 1

📷 Site Specific Photography Tips

If you enter the lagoon area from the east end in the morning, then walk to the west, you will have the sun to your back which is typically great for bird photography. In the late afternoon, just reverse this and enter the lagoon area from the west and travel to the east.

Bring a change of clothes and shoes. Most times, you will need to get wet crossing sections of shallow lagoons to orient yourself for the best light. Exercise great care when crossing the lagoons; make sure you can see the bottom as some sections are very deep.

At times, the abundance of birds is overwhelming. However, I find I can usually isolate a single bird or a pair for my photography. Watch the borders of your images for distracting elements such as bright shells or unwanted background items.

I prefer to shoot low to the ground; I have a homemade ground pod that I use for my long lenses. In addition, my tripod will lower to within a few inches of ground level for intimate images of the birds.

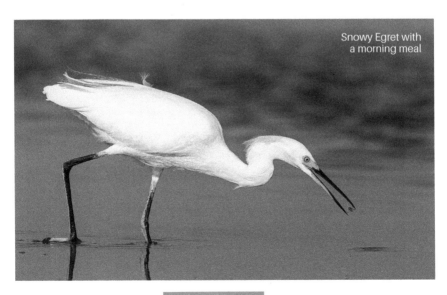

Snowy Egret with a morning meal

Fisheating Creek Wildlife Management Area, Moore Haven & Palmdale, FL
(Glades County)

MAP 1

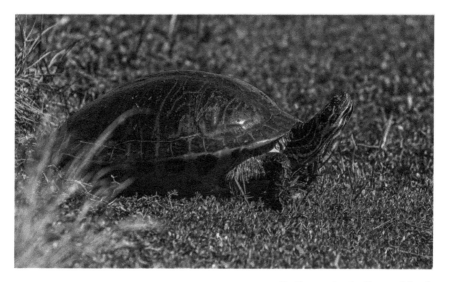

Turtle sunning by the creek bank

Site Specifics:

Fisheating Creek Wildlife Management Area, Eastern Entrance, Banana Grove Road at SR 78, Moore Haven, FL, and Western Entrance, 7555 US 27, Palmdale, FL. Website: https://myfwc.com/recreation/lead/fisheating-creek/

Fees: There are no entrance fees or parking fees for the eastern entrance of the wildlife management area. However, the Fisheating Creek Outpost at the western entrance does have a day-use fee in addition to RV and tent sites. Fees and hours of operation were current at the time of publication but subject to change; check the website for updates.

DESCRIPTION:

Fisheating Creek is north of the Caloosahatchee River and empties into Lake Okeechobee. Most of the western section is wetland and marsh area and the eastern section is upland and pine and oak hammocks. This entire area is best explored by canoe or kayak.

The Cowbone Marsh area, near the eastern entrance, is used by half the U.S. populations of swallow-tailed kites for roosting, nesting (in April and May), and raising their young before heading to South America in the early autumn. Sandhill Cranes and Crested Caracara are common in the prairies, pastures, and marshes. A variety of wading birds, such as ibises, Wood Storks, herons, egrets, and Roseate Spoonbills are also common in the marsh area.

Hawks, Osprey, Bald Eagles, and owls are also relatively common. During spring and fall migration, warblers are common, especially in the oak trees near the western entrance.

The creek hosts some of the largest alligators in Florida in addition to River Otters and a variety of turtles. The Florida Panther has also been spotted in the Fisheating Creek area on a few occasions.

MAP 1

📷 Site Specific Photography Tips

When photographing from a canoe or kayak, I prefer the versatility of a zoom lens and a single camera body. Good choices for zoom lenses include a 100-400mm or the popular 150-600mm. I prefer to carry my equipment in a dry bag and remove it when needed.

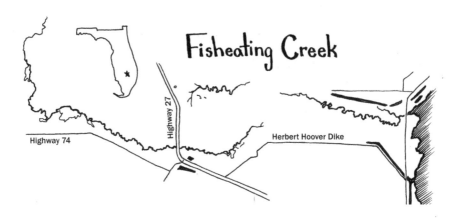

Fisheating Creek

Highway 27

Highway 74

Herbert Hoover Dike

Corkscrew Swamp Sanctuary, Naples, FL (Collier County)

MAP 1

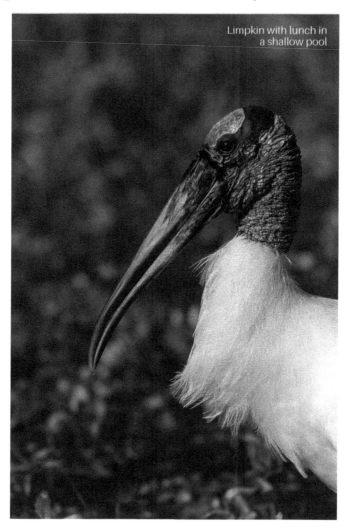

Limpkin with lunch in a shallow pool

Site Specifics:

Corkscrew Swamp Sanctuary, 375 Sanctuary Road West, Naples, FL. Telephone: 239-348-9151. Website: https://corkscrew.audubon.org/

Fees: The entrance fee for the sanctuary is $17 but there is a discount for Audubon members.

MAP 1

DESCRIPTION:

The sanctuary consists of 13,000 acres with the largest nesting colony of the endangered Wood Storks. The land was originally purchased by Audubon to protect the largest remaining Bald Cypress in North America. The original purchase, 3,000 acres, has been expanded to include the following habitats: Pine Flatwood, Wet Prairie, Sawgrass Pond, Lettuce Lake, and Marsh in addition to the Bald and Pond Cypress areas.

A raised boardwalk winds through these various habitats, beginning and ending at the nature center. Interpretive displays are found at strategic points along the boardwalk.

The boardwalk forms a large, contorted oval with the southern section passing through the Pine Flatwood, Sawgrass Pond, Pond Cypress, and Wet Prairie habitats. The northern sections pass through the Bald Cypress, Marsh, Lettuce Lake, and returns to the nature center through short sections of the Pond Cypress, Wet Prairie, and Pine Flatwood habitats.

Common sanctuary mammals include raccoons, Grey Squirrels, White-tailed Deer, and River Otters. The Florida Panther and Florida Black Bear cross through the sanctuary but are seldom seen. Reptiles include the American Alligator, Florida Red-belly Turtle, Pygmy Rattlesnake, Green and Brown Anole, and the Five-lined Skink.

Numerous birds are found in various habitats including raptors (Red-shouldered Hawk, Black and Turkey Vulture, Swallow-tailed Kite, and Barred Owl). In addition to the Wood Storks, other wading birds include the Green and Little Blue Heron, Great Egret, Black-crowned Night Heron, White Ibis, and Limpkin.

The American Bittern is occasionally seen in the marsh area; the Anhinga and Purple Gallinule are seen near any body of water. Many smaller birds, some migrants, and other permanent residents are located within the multiple habitats. These include the Red-bellied and Pileated Woodpeckers, Blue-gray Gnatcatcher, Eastern Phoebe, Great-crested Flycatcher, Carolina Wren, Painted Buntings, and many varieties of warblers.

MAP 1

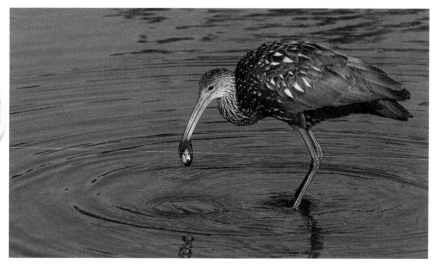

Limpkin with lunch in a shallow pool

📷 Site Specific Photography Tips

The sanctuary is a mixture of heavy overgrowth and wide-open spaces. Because the boardwalk is oriented roughly northeast to southwest, I prefer to concentrate on the northern sections of the boardwalk in the early mornings and the southern sections in the late afternoons.

I find a camera that can be hand-held to be more convenient than a tripod-mounted camera. Tripods tend to block portions of the boardwalk and can become a nuisance for some.

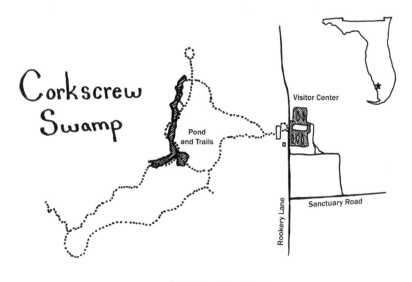

Corkscrew Swamp

Pond and Trails

Visitor Center

Rookery Lane

Sanctuary Road

HOTSPOT #17

Tigertail Beach, Marco Island, FL (Collier County)

MAP 1

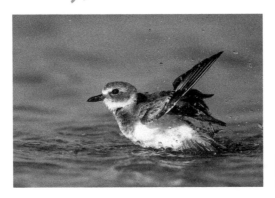

Plover taking bath at water's edge

Site Specifics:

Tigertail Beach, 430 Hernando Dr., Marco Island, FL. Telephone: 239-252-4000. Website: https://www.collierparks.com/collier_park/tigertail-beach-park/

Fees: There are no entrance fees; however, parking is $1.50/hour or $8 daily. Beach parking permits are available.

Hours: The beach is available 24 hours a day. Fees and hours of operation were current at the time of publication but subject to change; check the website for updates.

DESCRIPTION:

Tigertail Beach consists of a 32-acre strip of beautiful white sand beach that is split by a central tidal lagoon. The beach is named for Thlocklo Tustenuggee, a Florida Seminole Indian leader of the 2nd Seminole Indian War that wore a panther skin from his waist.

Florida Fish & Wildlife Conservation Commission rates Tigertail Beach as one of the best sites in Florida for birding. Wildlife includes wading birds such as herons and egrets, many varieties of shorebirds, gulls, terns, Roseate Spoonbills, Osprey, and Brown Pelicans. Occasionally, Bald Eagles and Falcons are observed.

Most prefer the gulf side of the tidal lagoon; however, crossing the lagoon can be hazardous. The lagoon is relatively deep and is flushed twice daily by incoming tides. Typically, avian activity is best on low tides, either dropping or incoming tides.

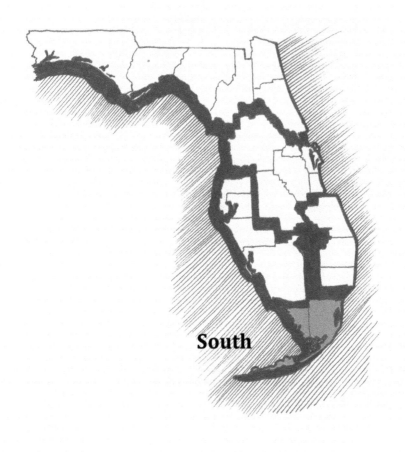

South

Big Cypress National Preserve and Fakahatchee Strand Preserve, Ochopee, FL
(Collier County)

MAP 2

Breathtaking sunset view across the preserve

Site Specifics:

Big Cypress Swamp Welcome Center, 33000 Tamiami Trail East, Ochopee, FL. Telephone: (239) 695-2000. Website: https://www.nps.gov/bicy/index.htm

Fees: There are no fees for entry and no parking fees unless you park on private or Indian land; however, there are fees for facilities and off-road permits.

Big Cypress National Preserve and Fakahatchee Strand Preserve are bisected in the north by interstate I-75 and bisected in the lower central area by US-41, Tamiami Trail. There are few established roads in the preserves but many trails are accessible with swamp buggies and ATVs. Street-legal 4x4s are permitted on some designated trails. One road, Janes Scenic Drive, off Route 29, crosses deep into parts of the Fakahatchee Preserve.

DESCRIPTION:

Fakahatchee and Big Cypress are made up of five different habitats. These include open prairies, pine stands, hardwood hammocks, estuaries, and Cypress swamps. I prefer the drive along US-41 (Tamiami Trail) to I-75. The pace is a bit slower and the connection to the landscape is more intimate.

Air plants, also known as epiphytes, are very abundant in the Bald Cypress trees along US-41. This is a landscape photographer's dream area with numerous areas begging for time from your digital or film cameras. Landscape photographer Clyde Butcher has made a career in this region with his view camera. Clyde has a few well-known galleries dotted around the state, including one in Ochopee.

Ochopee is also home to the smallest post office in the United States, a one-room building just large enough for the postal clerk (USPS Ochopee, 38000 Tamiami Trail East, Ochopee, FL 34141).

There are plenty of animals for the wildlife photographer. This is the home range of the Florida Panther, the Florida Black Bear is resident in these forests, bobcats are not uncommon and numerous birds are abundant in the area. Alligators are also common in the estuaries and swamps.

Everglades City, in the southwest corner of Big Cypress, is the gateway to the Ten Thousand Islands. The Ten Thousand Islands are located in the Gulf of Mexico just to the west of the Florida mainland. Many tour boats and boat launches are available for tours.

Many canoes make the trip from Everglades City to Sandfly Island in the Ten Thousand Islands. Dolphins and manatees are frequently observed as well as an abundance of wading birds. Avian wildlife is abundant on these islands as many of the islands serve as bird rookeries.

MAP 2

Everglades
(Collier, Dade, and Monroe Counties)

The Everglades is a massive area with three unconnected entrances: North or Shark Valley, South or Main Entrance at Florida City, and Northwest at Everglades City. This wetland preserve and the national park encompass most of the southern tip of Florida. The park consists of 1.5 million acres. It is composed of mostly sawgrass marshes, mangroves, and a few areas of pine-flatwoods.

Because of the size and the three entrances, I have divided the Everglades into three hotspots (#20-22). However, many factors are the same for all three hotspots so they will be covered in this introduction.

The Everglades has two distinct seasons, the dry (November through May) and the wet (June through October) seasons. During the winter dry season, cooler temperatures and less rainfall result in less flooding, dry sloughs, and lower water levels in the marshes and lagoons.

Because of the lower water levels, fish are concentrated attracting wading birds such as herons, egrets, ibis, and storks. Cooler temperatures also encourage alligators and crocodiles to increase their "sun" time on the boardwalks, trails, and paths.

During the summer wet season, the Everglades receive up to 65 inches of rain that can result in flooding of the marshes, sloughs, and other areas. Shallower areas will still attract a variety of wading birds. Alligators and crocodiles will spend more time in the water to avoid the summer heat.

The Everglades are teeming with wildlife. This includes marine animals, such as the West Indian Manatee and the endangered Leatherback Turtle. It also includes a variety of mammals including the seldom-seen Florida Panther, bobcat, and Florida Black Bear. Alligators, crocodiles, and pythons are also frequently seen. Numerous resident and migratory birds are found in the park. Entire books are filled with the variety of wildlife in the Everglades.

MAP 2

Everglades: Shark Valley Trails, Miami, FL (Dade County)

American Alligator swimming in canal

Site Specifics:

Shark Valley Welcome Center, 36000 SW 8th Street, Miami, FL. Telephone: 305-221-8776. Website: https://www.nps.gov/ever/planyourvisit/svdirections.htm

Shark Valley can be reached from Naples or Miami. The Naples approach has the advantage of more wildlife along the roadway between Everglades City and Shark Valley. There is a continuous canal on the north side of the road with an abundance of wading birds. This canal is easily approached as there is no fence and few obstacles.

Fees: Entrance fees for a private vehicle or vessel are $30 for a seven-day pass, motorcycles are $25, and pedestrians, cyclists, and paddle craft are $15 (for seven days). An annual pass for the Everglades is $55 and an annual pass for all National Parks is $80.

Hours: The entrance gate opens at 8:30 am and closes at 6 pm. The visitor center is open 9 am-5 pm. Fees and hours of operation were current at the time of publication but subject to change; check the website for updates.

MAP 2

DESCRIPTION:

Shark Valley consists of three trails. The Tram Trail is 15 miles and extends from the visitor center to the observation tower and back. The Bobcat Trail, 0.2 miles in length, is near the visitor center and the Otter Cave Trail, 0.3 miles, is roughly 0.6 miles from the visitor center but off the West Tram Trail.

A commercial tram is available for rides along the Tram Trail. Bicycles and walking are also an excellent way to explore the Tram Trail. Bring plenty of drinking water as there are no refreshments along the trails.

The Tram Trail consists of two 7–8-mile sections, the East Trail winds through the sawgrass prairie, and the West Trail follows the canal. Numerous birds and alligators can be seen on either trail. During the winter, it is not uncommon to see alligators sunning themselves on the boardwalks.

The Bobcat Trail transverses an area with magnolia, Cocoplum, Sweetbay, and Wax Myrtles. Much smaller resident and migrant birds are found in this area. The park reports that bobcats patrol the boardwalk at night; however, the area closes at 6 pm.

The Otter Cave Trail is a rough limestone trail that crosses a hardwood hammock with a few exposed areas with solution holes.

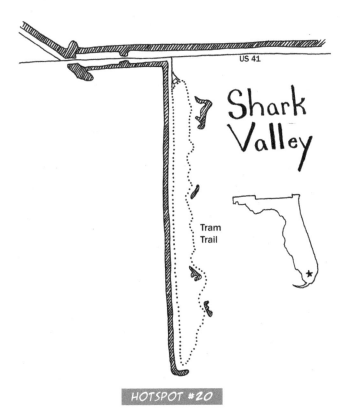

<div style="text-align: right">MAP 2</div>

US 41

Shark Valley

Tram Trail

Everglades: Anhinga Trail, Homestead, FL (Dade County)

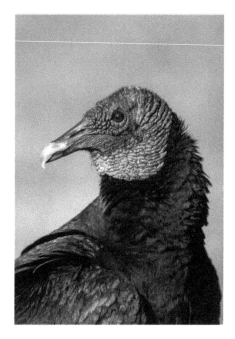

Black Vulture portrait

Site Specifics:

Everglades: Anhinga Trail, 40001 SR 9336, Homestead, FL. Telephone: 305-242-7700. Website: https://www.nps.gov/ever/planyourvisit/anhinga-trail.htm

Fees: Entrance fees for a private vehicle or vessel are $30 for a seven-day pass, motorcycles are $25, and pedestrians, cyclists, and paddle craft are $15 (for seven days). An annual pass for the Everglades is $55 and an annual pass for all National Parks is $80.

Hours: The main entrance is open 24 hours a day, 7 days a week. The visitor center is open from 8 am-5 pm from mid-December to mid-April and 9 am-5 pm from mid-April to mid-December. Fees and hours of operation were current at the time of publication but subject to change; check the website for updates.

Directions: From the Ernest Coe Visitor Center, at the main entrance to the Everglades, proceed 1.6 miles to Royal Palm Hammock. Turn left and proceed 1.9 miles to the parking area for Anhinga trail. Cover your vehicle with the provided blue tarps to protect it from the Black Vultures in the park area.

DESCRIPTION:

Anhinga trail is a 0.8-mile boardwalk over Taylor Slough. The terrain ranges from sawgrass marsh close to the boardwalk and more expansive areas of open water bordered by marches and islands with Pond Apples.

Wildlife along Anhinga trail is heavily dependent on the flood stage of the slough. When water is shallow enough, the area has a large abundance of wading birds such as herons, egrets, spoonbills, and storks.

Anhinga and Cormorants seem to always be in the area, either sunning in the Pond Apple trees or swimming in the slough. Alligators are also abundant in the dark water or on the banks of the marshes.

Black Vultures populate the parking area. At times, these vultures have been a problem as they peel off the rubber around the windshields of vehicles. Many photographers advise bringing a large tarp to cover your car during your visit to Anhinga trail. Some tarps are provided near the bathrooms for use by visitors.

MAP 2

📷 Site Specific Photography Tips

The boardwalk is sturdy and sufficiently wide for tripods, but many photographers elect to hand-hold cameras for better mobility. There are sufficient handrails to help steady your camera if needed.

I typically bring my 600mm prime lens on a tripod and a second camera body with a 100-400mm lens on a Black Rapid Strap. If I owned a longer zoom telephoto, such as 200-500mm, 150-600mm, or similar, I would only carry this single lens. On rare occasions, a 1.4x teleconverter can be helpful for detailed shots.

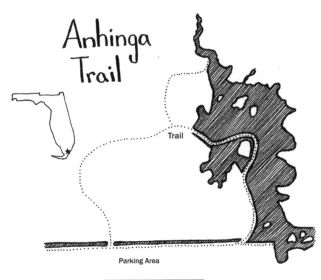

Anhinga Trail

Trail

Parking Area

Everglades: Flamingo, Homestead, FL (Monroe County)

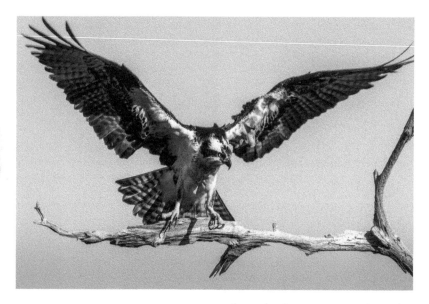

Osprey lands on a snag near the marina

Site Specifics:

Everglades: Flamingo, 1 Flamingo Lodge Hwy., Homestead, FL. Telephone: 239-695-2945. Website: https://www.nps.gov/ever/planyourvisit/flamdirections.htm

Fees: Entrance fees for a private vehicle or vessel are $30 for a seven-day pass, motorcycles are $25, and pedestrians, cyclists, and paddle craft are $15 (for seven days). An annual pass for the Everglades is $55 and an annual pass for all National Parks is $80.

Hours: The main entrance is open 24 hours a day, 7 days a week. The visitor center is open from 8 am-4:30 pm from mid-December to mid-April. Hours are intermittent during the off-season (mid-April to mid-December). Fees and hours of operation were current at the time of publication but subject to change; check the website for updates.

Directions: From the Ernest Coe Visitor Center, at the main entrance to the Everglades, proceed 38 miles to Flamingo along Main Park road. The road dead-ends at Flamingo.

DESCRIPTION:

Flamingo is a true ghost town as no one lives full-time in Flamingo. However, there is a hotel that is usually busy during the winter season; however, this hotel appears to be closed at this time and is under renovation. In addition to the hotel, there is a marina, concessions, boat tours, gas station, canoe, and kayak rentals, and food service during the winter season.

The former city of Flamingo was a coastal city at the eastern end of Cape Sable. All that remains of the former city are a few foundations.

Manatees, alligators, crocodiles, and Osprey are prevalent near the marina. At times, Eco Pond is teeming with birds; other times, it can be a complete bust. However, it is easily accessed, so it is worthy of a look anytime you are near Flamingo.

To truly see an abundance of wildlife, take a canoe or kayak from the marina into the swamps. Numerous wading birds, such as herons, egrets, and spoonbills are available. Alligators and turtles also are abundant in the water and along the banks.

MAP 2

PAUROTIS POND:

Paurotis Pond, located 24 miles from the visitor center and 14 miles from Flamingo, is a nesting area for Wood Storks, Roseate Spoonbills, White Ibis, and Great Egrets. Nesting begins in early winter and extends into early summer. There is an observation platform at Paurotis Pond and a boat launch; however, the boat launch is frequently closed during nesting season.

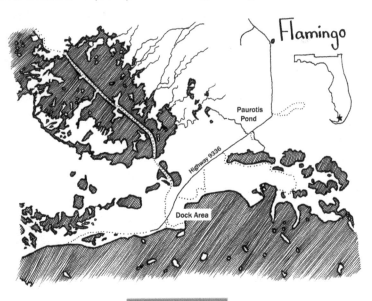

HOTSPOT #22

John Pennekamp Coral Reef State Park, Key Largo, FL
(Monroe County)

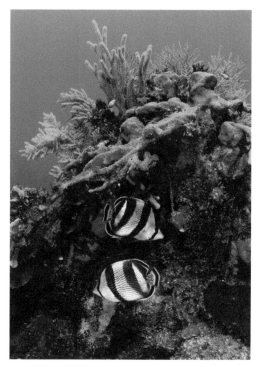

Image courtesy of Karen Doody.

Banded Butterfly Fish swimming near reef

Site Specifics:

John Pennekamp Coral Reef State Park, 102601 Overseas Highway, Key Largo, FL. Telephone: 305-676-3777. Website: https://www.floridastate-parks.org/parks-and-trails/john-pennekamp-coral-reef-state-park

Fees: Park entrance requires payment of a fee that depends on the number of occupants in your vehicle. Entrance fees for one person per vehicle are $4.50, two persons in a single vehicle are $8 plus $0.50 per extra occupant up to eight, and pedestrians or bicyclists are $2.50. An annual state parks pass is available for Florida Parks; it is an excellent value if you plan many visits to the state parks.

The boat ramp fee is $10/day. Fees and hours of operation were current at the time of publication but subject to change; check the website for updates.

MAP 2

DESCRIPTION:

Coral reef diving, either scuba or snorkel, is an experience that should be on everyone's bucket list. You will never forget the views and the feeling of being among all the vibrant, colorful life of the undersea world. I learned how to dive many years ago, but my only experience at Pennekamp has been snorkeling. It was magical and unforgettable.

Glass-bottom boats, snorkel, and traditional dive trips are available in the park. The glass-bottom boats are an excellent option for those of limited abilities; however, there is also a wheelchair boat trip for those that wish to snorkel but are confined to a wheelchair.

Boat trips leave a couple of times a day, a round trip to the coral reef is typically an hour so a 2.5-hour trip will include 1.5 hours of reef time. An abundance of equipment is available for rent.

PADI dive training is also available on-site for those wishing to earn their dive certificate and experience the park.

MAP 2

📷 Site Specific Photography Tips

Some form of camera protection will be needed, such as an EWA camera housing or an Ikelite housing. EWA is more budget-friendly with prices in the $300 range for specific cameras. An Ikelite housing starts at approximately $1,600 plus accessories.

Good quality, fast, wide-angle lenses are traditionally used for underwater photography. Because of light loss, loss of contrast, and debris in the water, you will be photographing animals and coral very close; usually less than 12 inches. Preset all your controls from the safety of the boat; once in the water, it will be more difficult to change ISO, aperture, shutter speed, and other functions.

If you have a digital camera, plan to photograph using live view. This will give you a large screen for composition. I shoot in raw format and auto white balance. Then I color correct the color cast in post-production. However, I am strictly an amateur underwater photographer, so my recommendations are based on my very limited experience.

Image courtesy of Karen Doody.

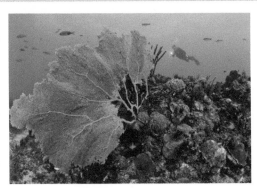
Fanscape

Big Pine Key, Florida Keys, FL
(Monroe County)

MAP 2

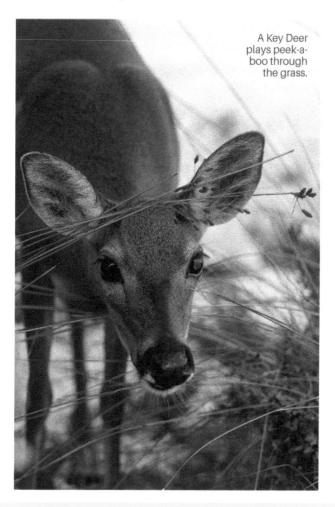

A Key Deer plays peek-a-boo through the grass.

Site Specifics:

National Key Deer Refuge, 30587 Overseas Highway, Big Pine Key, FL. Website: https://www.fws.gov/refuge/national_key_deer_refuge/

Fees and Hours: There are no fees for entry and no parking fees. There are no set hours for entry as the area is open. The Key Deer Refuge is located on Big Pine Key, but the Key Deer are spread across numerous keys including Big Pine, Cudjoe, No Name, and Sugarloaf.

DESCRIPTION:

Key Deer are one of the dramatic success stories of the Endangered Species Act. The Key Deer population was reduced to a few dozen animals in 1950 but through extensive protection, the population is now stable and healthy. Over 1,000 Key Deer are scattered across numerous islands or keys in the lower Florida Keys.

Key Deer are the smallest subspecies of White-tailed Deer with males (bucks) reaching a weight of approximately 80 pounds and standing about three feet in height. Females (does) are a bit smaller and lighter. Key Deer are specially adapted to the salt-tolerant foliage of the lower Florida Keys.

Other endangered or threatened species located in the lower keys include the Lower Keys Marsh Rabbit, Great White Heron, White-crowned Pigeon, and sea turtles including the Green, Hawksbill, Atlantic Ridley, Loggerhead and Leatherback.

MAP 2

📷 Site Specific Photography Tips

The deer are scattered around the island but the largest concentration I have routinely had success photographing was near the former Lions Club at 4450 Key Deer Boulevard on Big Pine Key. This building is no longer occupied by the Lions Club, but the area is frequently visited by the deer.

The deer are habituated to humans and forage among the houses and properties on the island. A moderate telephoto will capture full-frame images of the deer. I enjoy capturing early morning or late afternoon images of the deer.

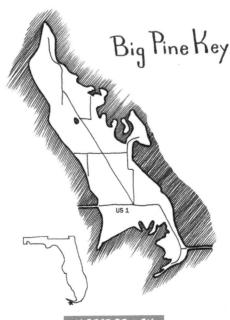

Big Pine Key

US 1

HOTSPOT #24

Key West & Dry Tortugas, Florida Keys, FL (Monroe County)

MAP 2

Marker in Key West for the southernmost point of land in the continental United States

Site Specifics:

Southernmost Marker, Corner of Whitehead and South Street, Key West, FL

Mallory Square, 400 Wall Street, Key West, FL

Jimmy Buffett's Margaritaville Café, 500 Duval Street, Key West, FL

Ernest Hemingway Home and Museum, 907 Whitehead Street, Key West, FL

Dry Tortugas Ferry (Yankee Freedom II), 100 Grinnell Street, Key West, FL

Dry Tortugas Seaplane (Key West Seaplane Adventures), 3471 South Roosevelt Boulevard, Key West, FL

Fees: There are no entry or parking fees for most locations. However, parking can be challenging because of the number of tourists and limited parking.

DESCRIPTION:

Like most of Florida, most of the beaches have a variety of gulls, pelicans, and a few wading birds. However, the primary wildlife in Key West is humans. Key West has always attracted an eclectic mix of authors, liveaboard boaters, drop-outs, musicians, and others following their own path in life. Ernest Hemingway was a frequent resident as was Jimmy Buffett.

Sunsets at Mallory Square are a nightly ritual. Numerous musicians, street performers, and others collect at sunset to entertain and be entertained. Some are looking for a "bit of coin" for their talents, I usually oblige for those that do well and earn it.

DRY TORTUGAS NATIONAL PARK:

MAP 2

The Dry Tortugas is a 100-acre park, multiple small islands, and Fort Jefferson. Numerous birds visit the Tortugas during spring and fall migrations. Green and Loggerhead Turtles nest on the islands. The waters surrounding the Tortugas provide some of the best coral reef snorkeling or diving. Camping is permitted on Garden Key.

The Tortugas can only be reached by boat or seaplane as no bridges connect Key West to the Tortugas.

📷 Site Specific Photography Tips

See recommendations for underwater photography as part of Hotspot #23, John Pennekamp Coral Reef State Park.

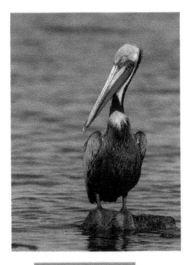

Brown pelican standing on rock in the Florida Keys

HOTSPOT #25

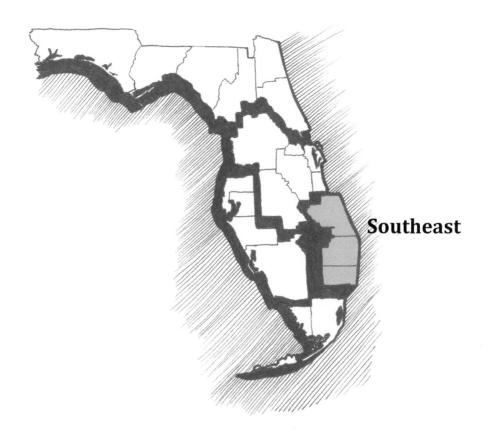

Southeast

Brian Piccolo Park, Cooper City, FL (Broward County)

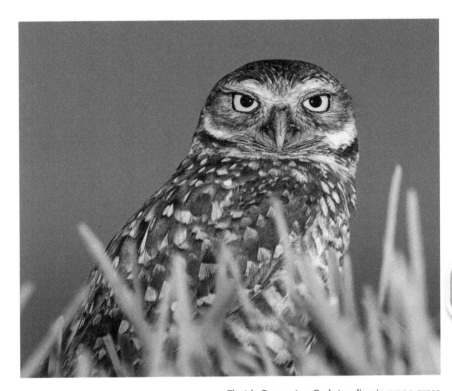

Florida Burrowing Owl standing in green grass

MAP 3

Site Specifics:

Brian Piccolo Park, 9501 Sheridan Street, Cooper City, FL. Telephone: 954-357-5150. Website: https://www.broward.org/Parks/Pages/park.aspx?park=4

Fees: No admission fees are charged on weekdays, but holidays and weekends are $1.50 per person and an $8 maximum charge per vehicle with up to nine occupants.

Hours: Monday through Saturday 8 am – 6 pm; Sunday 9 am – 5:30 pm. Fees and hours of operation were current at the time of publication but subject to change; check the website for updates.

DESCRIPTION:

Brian Piccolo Park, named for the 1960's football star from Broward County, is a 175-acre park with numerous soccer, cricket, baseball, and other sports fields. The major attraction for wildlife enthusiasts is Burrowing Owls in addition to Red-tailed Hawks, Loggerhead Shrikes, Red-bellied Woodpeckers, a few songbirds, ducks, and the nearly ubiquitous grey squirrels.

Burrowing Owls can be found near most of the athletic fields. They are delineated with stakes and flags. Some are relatively near the activity areas and others are outside the fences and in adjacent areas. The park staff is considerate of the owls and maintains the barriers.

Pair of immature Burrowing Owls

MAP 3

📷 Site Specific Photography Tips

Most Burrowing Owls sites are in safe places for photography. The grass is well manicured in the park making low-level images a joy. I like using a ground pod for images nearly at grass level. Some sites have raised hills making it possible to get a cleaner background.

Early morning and late afternoon soft light will be ideal. There will be less traffic from folks using the sporting fields on weekdays and in the mornings.

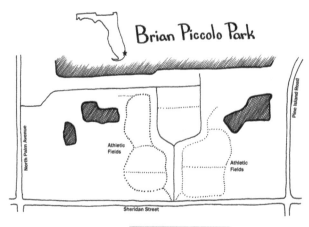

HOTSPOT #26

Wakodahatchee Wetlands, Delray Beach, FL
(Palm Beach County)

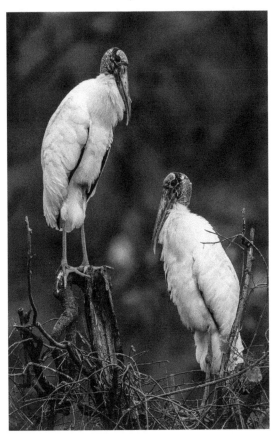

Pair of
Wood Storks
on snags

MAP 3

Site Specifics:

Wakodahatchee Wetlands, 13270 South Jog Road, Delray Beach, FL.
Telephone: 561-493-6000. Website: https://discover.pbcgov.org/wateruti-
lities/pages/wetlands.aspx

Fees and Hours: There are no fees for entry and no parking fees. The
wetlands are open from 6 am till 6 pm. Fees and hours of operation were
current at the time of publication but subject to change; check the website
for updates.

DESCRIPTION:

Wakodahatchee Wetlands is a 50-acre park on the property of a former waste-water utility. It consists of a ¾-mile boardwalk over shallow ponds. There are numerous islands and shrubs filled with nesting and roosting birds.

The boardwalk is approximately three feet above the water level and the trees and islands are typically 50 feet or more from the boardwalk area. Alligators, turtles, cormorants, Anhinga, coots, moorhens, wading birds, and Purple Gallinules are common in the ponds.

Roosting and nesting wading birds are common in the trees. Iguanas share the trees with the nesting Wood Storks. Rabbits, raccoons, and wading birds use the land bridges between the ponds.

Iguana sharing
a tree with
Wood Storks

MAP 3

📷 Site Specific Photography Tips

A lens of at least 600mm will be needed to capture full-frame images of the Wood Storks in the nesting trees. Mating Wood Storks can be captured with 400mm. Medium to long focal lengths are excellent for photographing the wading birds on the land bridges. Longer lenses, such as 600mm are best for raccoons and rabbits.

I prefer to take images at the animals' eye-level. That will be difficult for any birds or animals in the water, at this facility, because of the height of the boardwalk above the water level.

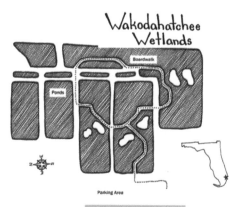

Wakodahatchee
Wetlands

Boardwalk

Ponds

Parking Area

HOTSPOT #27

Green Cay Nature Center and Wetlands, Boynton Beach, FL
(Palm Beach County)

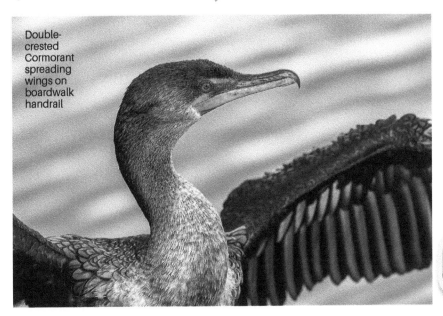

Double-crested Cormorant spreading wings on boardwalk handrail

MAP 3

Site Specifics:

Green Cay Nature Center and Wetlands, 12800 Hagen Ranch Road, Boynton Beach, FL. Telephone: 561-493-6000. Website: https://discover.pbcgov.org/parks/pages/Greencay.aspx

Fees and Hours: There are no fees for entry and no parking fees. The boardwalk is open from sunrise to sunset. Restrooms are accessible from 7 am to 7 pm. Fees and hours of operation were current at the time of publication but subject to change; check the website for updates.

DESCRIPTION:

The boardwalk crosses approximately 100 acres of wetland ponds and a few land bridges. The height of the boardwalk ranges from 18 to 30 inches above the water level. Generally, most straight sections are closer to the water level and the gazebos and crossing areas are at a higher level.

Low wetland vegetation is abundant. This includes Fireflag, Arrowhead, Arrow Arum, and Pickerelweed. Some areas of pond lilies, such as Spatterdock are also evident. Because of this abundance of low wetland vegetation, many birds are abundant at Green Cay.

This includes Red-winged Blackbirds, Sora, Limpkins, Black-bellied Whistling Ducks, Roseate Spoonbills, Least Bitterns, Yellow and Black-crowned Night Herons and cormorants so tame you can touch their tails as they sit on the boardwalk railing (don't do it, not only is it illegal but the birds do not like it).

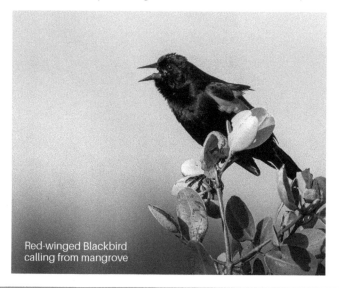

Red-winged Blackbird
calling from mangrove

MAP 3

📷 Site Specific Photography Tips

Portraits of cormorants can be obtained with a 50-85mm lens; the birds are exceedingly tame. Longer telephotos are useful for the birds in the water and along the ground bridges. The separation between the railing boards on the boardwalk is approximately 4 inches, and this makes it excellent to get low to the water for images of the birds with a moderate telephoto lens.

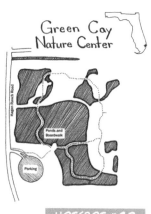

Green Cay
Nature Center

Hagen Ranch Road

Ponds and
Boardwalk

Parking

Arthur R. Marshall Loxahatchee National Wildlife Refuge, Boynton Beach, FL
(Palm Beach County)

Textures of the Cypress Swamp including Cypress tree bark, epiphytes or air plants and Cypress knees

MAP 3

Site Specifics:

Arthur R. Marshall Loxahatchee National Wildlife Refuge, 10216 Lee Road, Boynton Beach, FL. Telephone: 561-732-3684. Website: https://www.fws.gov/refuge/arm_loxahatchee/

Fees: A one-day pass for a private vehicle is $10; this covers the driver and all occupants. An annual pass is $25 but only covers the pass holder. Admission is free with an interagency annual pass (National Parks, National Wildlife Refuges, etc.).

Hours: The refuge is open from 5 am to 10 pm. Fees and hours of operation were current at the time of publication but subject to change; check the website for updates.

DESCRIPTION:

Loxahatchee consists of approximately 145,000 acres of wet prairies, cypress swamp, and marsh. It is the northeast corner of the former extent of the Everglades.

The refuge consists of two hiking trails, the Cypress Swamp Boardwalk Trail, and the Marsh Trail. There is also a Canoe Trail that winds through the wetland area. I was amazed at the textures and diversity of vegetation along the Cypress Swamp Boardwalk. This is a walk to do on a relaxing day and enjoyed at a slow pace.

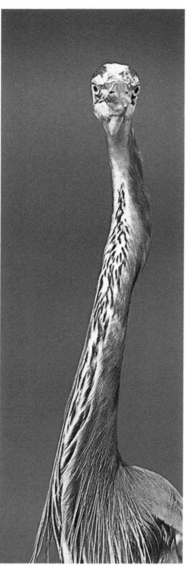

Great Blue Heron with a long neck stretch

MAP 3

HOTSPOT #29

The Marsh Trail winds through the open prairie area and includes wetland vegetation, wading birds, the occasional alligator, and a few mammals such as raccoons, rabbits, and bobcats. Snail Kites and Wood Storks are also common visitors.

Winter waterfowl and migratory birds are common. The Pig Frogs sing frequently in the lily ponds which are located just past the impoundments.

📷 Site Specific Photography Tips

Photography along the Cypress Swamp Boardwalk is mostly good as the boardwalk is approximately a foot or less above the water level. Part of the boardwalk railing is vertical slats making it easy to take images low to the water surface. Other parts of the railing are chain-link fencing making images low to the water difficult.

The Marsh Trail is at ground level, so photography is ideal. Most moderate to long telephoto lenses will be useful on the Marsh Trail. Most of the other areas of the refuge are very accessible and permit photographers to approach the water-edge and get low to the ground.

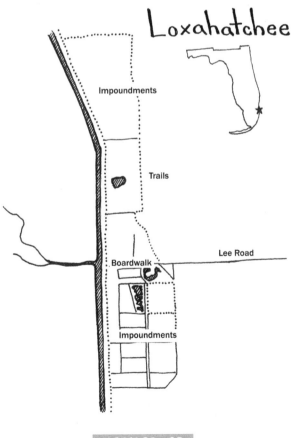

Loxahatchee

Impoundments

Trails

Boardwalk

Lee Road

Impoundments

MAP 3

Jonathan Dickinson State Park, Hobe Sound, FL (Martin County)

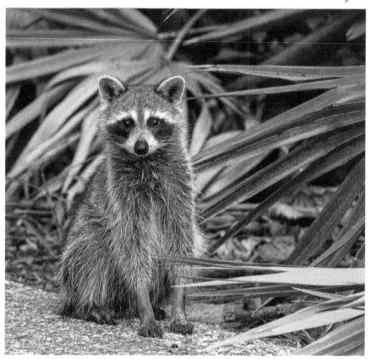

Raccoon standing under cover of palmetto fronds

MAP 3

Site Specifics:

Jonathan Dickinson State Park, 16450 SE Federal Highway, Hobe Sound, FL. Telephone: 772-546-2771. Website: https://www.floridastateparks.org/parks-and-trails/jonathan-dickinson-state-park

Fees: Park entrance requires payment of a fee that depends on the number of occupants in your vehicle. Entrance fee for one person per vehicle is $4, two to eight persons in a single vehicle are $6 and pedestrians or bicyclists are $2. An annual state parks pass is available for Florida Parks; it is an excellent value if you plan many visits to the state parks. The boat ramp fee is $4 in addition to the entry fee.

Hours: The refuge is open from 8 am to sunset, 365 days per year. Fees and hours of operation were current at the time of publication but subject to change; check the website for updates.

DESCRIPTION:

Jonathan Dickinson State Park is the largest state park in southeast Florida with an area of approximately 11,500 acres. Highway U.S. 1 and the Atlantic Ocean form the eastern boundary and the Loxahatchee River forms the southwestern boundary.

There are four nature trails in addition to numerous off-road, bicycle, and horse trails. One-fifth of the park is "sand pine scrub" and home to endangered species such as the Florida Scrub-jay, Florida Mouse, Gopher Tortoise, and Gopher Frog. The other four-fifths of the park consists of wet prairies, dome swamps, and flatwoods.

Opossums, alligators, raccoons, foxes, and otters are the other common mammals of the park. Common smaller birds include the White-eyed Vireo, Blue Jay, Fish Crow, Palm and Pine Warbler, Yellow-rumped Warbler, Northern Parula, Carolina Wren, Chimney Swift, Great-crested Flycatcher, and Downy Woodpecker.

Common larger birds include Double-crested Cormorant, Anhinga, Mottled Duck, Wild Turkey, Great Blue and Little Blue Herons, Great and Cattle Egrets, White Ibis, Osprey, Red-shouldered Hawk, American Kestrel, Sandhill Crane, Common Moorhen in addition to Barred and Eastern Screech Owls.

A concessionaire is available that rents canoes, kayaks, motorboats, bicycles, horses and offers tours of the Loxahatchee River.

MAP 3

Endangered Florida Scrub-jay perched on a branch

Cattle Egret
portrait

📷 Site Specific Photography Tips

Because of the open nature of the park, moderate to long telephoto lenses are effective. Much of the photography will be completed while hiking, bike riding, or in a small boat so a relatively fast zoom telephoto is an excellent choice. Also, wide-angle lenses are great for sunrises and sunsets of the landscape.

MAP 3

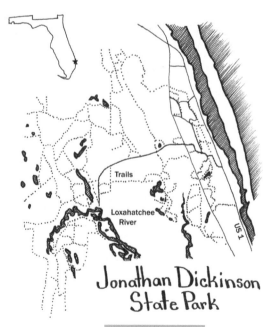

Trails

Loxahatchee
River

US 1

Jonathan Dickinson
State Park

HOTSPOT #30

CENTRAL REGION
COVERING HOTSPOTS #31-42

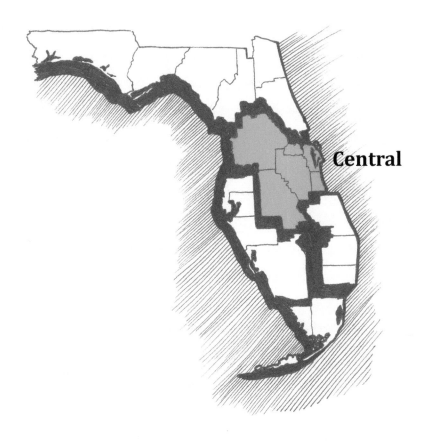

Central

Loggerhead Marinelife Center
(Palm Beach County) **& Archie Carr
National Wildlife Refuge**
(Brevard and Indian River Counties)

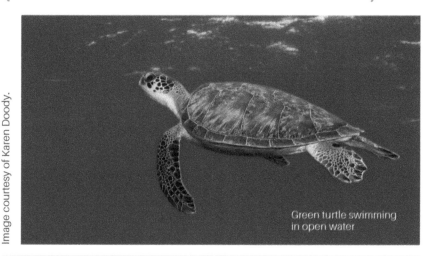

Image courtesy of Karen Doody.

Green turtle swimming
in open water

Site Specifics:

Loggerhead Marinelife Center and Archie Carr National Wildlife Refuge are two sites to observe and volunteer to help endangered sea turtles. The best times to volunteer to help with the turtles are June through July with the Sea Turtle Watch Programs. Inquire at Loggerhead Marinelife Center or Barrier Island Sanctuary Management and Education Center.

Loggerhead Marinelife Center, 14200 US Highway 1, Juno Beach, FL. Telephone: 561-627-8280. Website: https://marinelife.org. The center is open from 10 am to 5 pm. There is no fee for entry, but a $5 donation is suggested.

Archie Carr National Wildlife Refuge: information is available at Archie Carr NWR, c/o Everglades Headwaters NWR Complex, 4055 Wildlife Way, Vero Beach, FL 32963. Telephone: 772-581-5557. Website: http://www.fws.gov/ArchieCarr

Barrier Island Sanctuary, 8385 South Highway A1A, Melbourne Beach, FL. Telephone: 321-723-3556. Website: http://www.barrierislandcenter.com. Sanctuary hours are 9 am to 5 pm; closed on Mondays and holidays. There is no fee for entry.

MAP 4

DESCRIPTION:

Loggerhead Marinelife Center serves the community with education and outreach to aid in the conservation of lands and protection of sea turtles. The center hosts thousands of school children to help educate them about marine life and our threatened ecosystems.

The center is also open for tourists and visitors. In addition to education outreach, the center also provides veterinary services for injured turtles and serves as the only sea turtle hospital between Orlando and the Florida Keys.

The Archie Carr National Wildlife Refuge is not a single place; it is a consortium/partnership of federal, state, county, and private landowners that help protect the 20.5 miles of the refuge that spans from Wabasso Beach located in Indian River County to Melbourne Beach in Brevard County. Numerous parks are located along the Atlantic Ocean and the Intercoastal Waterway. These are united in purpose with strict regulations to protect the turtle habitat.

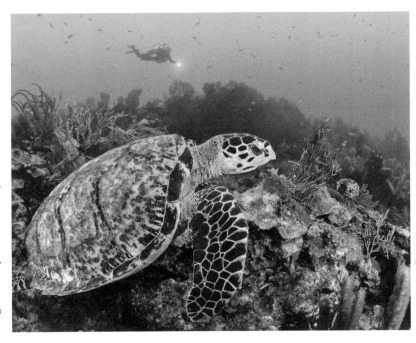

Image courtesy of Karen Doody.

MAP 4

📷 Site Specific Photography Tips

Photography is not allowed when working or visiting the sea turtles on the beach. However, assisting with sea turtles is a memory that will last a lifetime.

Pelican Island National Wildlife Refuge, Vero Beach, FL
(Brevard County)

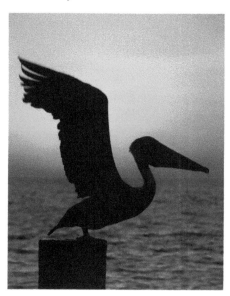

Brown Pelican
taking flight
from post

Site Specifics:

Pelican Island National Wildlife Refuge, 4055 Wildlife Way, Vero Beach, FL. Telephone: 772-581-5557. Website: https://www.fws.gov/pelicanisland/

Hours and Fees: Sunrise to sunset; there is no fee for entry. Fees and hours of operation were current at the time of publication but subject to change; check the website for updates.

Directions: Take US Highway A1A 3.7 miles north of Wabasso Beach Road (CR 510), turn left on Historic Jungle Trail, and follow this trail around to the walking trails.

DESCRIPTION:

Pelican Island was established as the first refuge by President Theodore Roosevelt to protect the last remaining pelican rookery on Florida's east coast. The refuge consists of 5,400 acres, one driving trail, and four walking trails.

The Historic Jungle Trail is part of the main entrance and travels through the underbrush. The walking trails include the Joe Michael Memorial Trail, Bird's Impoundment Trail, Wildlife Trail, and Centennial Trail.

Pelican Island and the surrounding area serve as habitat to over 100 species of birds, some of which nest on the island. The best times for observing the birds on the island are November through March.

Birds nesting on the islands include Wood Stork, Double-crested Cormorant, Anhinga, Brown Pelican, Mottled Duck, Magnificent Frigatebird, herons (Great Blue, Little Blue, Tricolored, Green and both Yellow and Black-crowned Night Herons), egrets (Cattle, Snowy, and Great Egrets), White Ibis, Roseate Spoonbill, Osprey, and American Oystercatchers.

Access to Pelican Island is prohibited but canoes and kayaks can approach the boundary that is 410 feet from the shoreline. In addition to the numerous birds, River Otters, Gopher Tortoises, Blue Land Crabs, bobcats, raccoons, and a few other animals are frequent visitors.

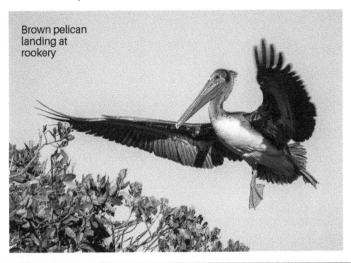
Brown pelican landing at rookery

MAP 4

📷 Site Specific Photography Tips

Because of the restrictions for the island, it is difficult to get close enough for photography, but flight photography is very productive. Use long lenses, such as 600mm, and set your shutter speed at 1/1000 sec or higher. Roosting birds begin leaving the island at first light.

Photography on the hiking and driving trails is also productive. Many times, I can photograph some of the migrating birds in the trees and shrubs on the Historic Jungle Trail using a moderate to long telephoto lens.

Many of the birds from the rookery island will also visit the mainland and the lagoon. Pelicans regularly hunt for food in the lagoon and at times, Osprey and pelicans will also visit the mainland.

Viera Wetlands, Viera, FL
(Brevard County)

Great Egret at Viera Wetlands

Site Specifics:

Viera Wetlands, 3658 Charlie Corbeil Way, Viera, FL. Telephone: 321-633-2016. Website: https://www.brevardfl.gov/NaturalResources/EnvironmentalResources/Viera Wetlands

Hours: November-January 7 am-6 pm; April-September 6 am-8 pm; February, March & October 7 am-7 pm

Fees: There are no fees for entry but at times, the roads are closed because of wet conditions. Fees and hours of operation were current at the time of publication but subject to change; check the website for updates.

DESCRIPTION:

Viera Wetlands consists of 200 acres that is divided into lakes or cells, each cell is approximately 35 acres. Four cells surround a central lake. Roads, suitable for driving when there is not rainy weather, divide the cells and make travel a breeze around the property.

MAP 4

The wetlands are one of the premier Florida East Coast hotspots with an abundance of birds and reptiles. Birds that are plentiful at the wetlands include numerous wading birds such as egrets and herons. Ducks, moorhens, coots, and other wetland wildlife abound. Caracara and Bald Eagles are also common. Alligators and turtles are common.

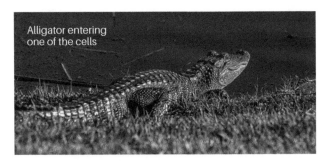

Alligator entering one of the cells

📷 Site Specific Photography Tips

The wetlands open early enough for good morning light and stay open long enough for evening light. I have found the staff to be welcoming of photographers and birders.

Approaches to the cells are relatively gentle making it convenient to get near water level; watch for alligators. Moderate telephoto lenses are good for the ducks, coots, moorhens, and other waterfowl.

Longer telephoto lenses are best for the Bald Eagles and Caracara. At times, it is best to shoot from your vehicle as the birds of prey tend to be a bit more skittish. I like using a bean bag with my 600mm.

Reptiles, such as turtles and alligators, can be photographed with nearly any lens in your kit. Both seem habituated but best to use the longer lenses for the alligators.

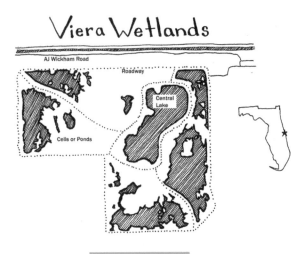

Viera Wetlands

AJ Wickham Road

Roadway

Central Lake

Cells or Ponds

MAP 4

HOTSPOT #33

Merritt Island National Wildlife Refuge, Titusville, FL
(Brevard County)

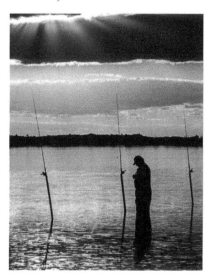

Fisherman
in lagoon on
Merritt Island

Site Specifics:

Merritt Island National Wildlife Refuge, Black Point Drive, Titusville, FL. Telephone: 321-861-0669. Website: https://fws.gov/merrittisland

Fees: There is a $10 fee per day for entry but there is no manned collection booth. Payment can be made online or at the refuge visitor center located at 1987 Scrub Jay Way, Titusville, FL. An annual pass is $25, and the National Park Annual Pass also covers entry.

Hours: The refuge is open sunrise to sunset, 365 days a year but closed during launches from Cape Canaveral. Fees and hours of operation were current at the time of publication but subject to change; check the website for updates.

Refuge Directions: From I-95, take exit 220 (SR 406), head east four miles and cross the Max Brewer Causeway Bridge. The refuge is the first turn to the left past the causeway.

Manatee Observation Deck: County Road 3 at Haulover Canal, Mims, FL. From I-95, take exit 220 (SR 406) toward Titusville for 14.4 miles, turn left on County Road 3 and continue 4.5 miles, turn right into the parking area.

MAP 4

DESCRIPTION:

Black Point Drive at Merritt Island National Wildlife Refuge is one of the premier wildlife hotspots in Florida. I would certainly rate it among my top five for the state. The refuge consists of approximately 140,000 acres of primarily wetland habitat with an abundance of birds, alligators, and mammals.

Habitats include saltwater estuaries, freshwater lagoons, marshes, dunes, scrub, and hardwood hammocks. Wading birds, such as Roseate Spoonbills, numerous varieties of herons and egrets, Wood Storks, Anhinga, and Double-crested Cormorants are frequently observed.

In the early spring, I have seen alligators so plentiful you could almost walk across the water from one alligator to the next. However, this is something I would not recommend as I have seen many alligators that exceed 8 feet in length.

Landscapes in this area are a landscape photographer's dream. Sunrises and sunsets seem to be especially colorful in this area. Just a few miles across the waterway are the Cape Canaveral launch pads.

Manatees are prevalent at the Haulover Canal most times of the year. This is located just a few miles past the refuge and the observation deck is an excellent place to view these "sea cows."

📷 Site Specific Photography Tips

Moderate to long lenses are best for the wildlife at the refuge. It is possible to photograph many of the birds from the comfort of your vehicle using a bean bag. This will hide the human form thereby providing an abundance of time for photography.

Birds at water level, mammals, and alligators will be best photographed from the banks of the lagoons. Do keep a sharp eye for unseen alligators; they like to hide in the brush. Before I get low to the water edge, I do a thorough observation for alligators.

MAP 4

Merritt Island N.W.R. - Black Point Dr.

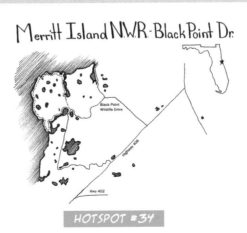

Black Point Wildlife Drive

Highway 406

Hwy 402

HOTSPOT #34

Lake Kissimmee State Park, Lake Wales, FL (Polk County)

An intimate portrait of a White-tailed deer

Site Specifics:

Lake Kissimmee State Park, 14248 Camp Mack Road, Lake Wales, FL. Telephone: 863-696-1112. Website: https://www.floridastateparks.org/parks-and-trails/lake-kissimmee-state-park

Fees: Park entrance requires payment of a fee that depends on the number of occupants in your vehicle. Entrance fees for one person per vehicle are $4, two to eight persons in a single vehicle are $5 and pedestrians or bicyclists are $2. An annual state parks pass is available for Florida Parks; it is an excellent value if you plan many visits to the state parks. The boat ramp fee is $4 in addition to the entry fee.

Hours: The refuge is open from 8 am to sunset, 365 days per year. Fees and hours of operation were current at the time of publication but subject to change; check the website for updates.

DESCRIPTION:

Lake Kissimmee State Park is an approximate 6,000-acre park consisting of mostly pine flatwoods with palmetto. It also contains lake access. Much of the park is low scrub and habitat to numerous White-tailed Deer in addition to armadillo, bobcats, turkey, Grey Fox, fox squirrels, tortoises, and over 200 species of birds.

MAP 4

There are over 13 miles of hiking trails and six miles of equestrian trails that bisect the park. A public use fishing dock is located at the lake and worms are available from the small store near the lake.

The highest concentration of White-tailed Deer is near the Cow Camp area. Wild turkeys are most common crossing the trails and the entry road; however, I have seen them, on occasion, near the roadside. Bald Eagles and Sandhill Cranes are relatively common, Snail Kites are near the lake and Crested Caracara are occasionally seen.

A checklist of birds is available from the entry gate listing over 200 avian species that range from common to rare. I have a passion for endangered species; the Florida Scrub-jay and Snail Kites are seen occasionally.

Gopher Tortoise

📷 Site Specific Photography Tips

The White-tailed Deer are relatively common near the Cow Pen area. I have had the best luck photographing them from my vehicle using a moderate telephoto lens. Generally, if you park at the side of the road and wait, they will move from the dense cover of the palmettos to more open areas.

Gopher Tortoises are best photographed at the animals' eye-level; of course, this is ground level. The tortoises are fairly habituated. I use a 100-400mm lens and remain about 15 feet from the tortoises for some great frame-filling images.

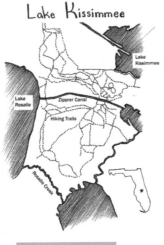

Lake Kissimmee

Lake Kissimmee

Lake Rosalie

Zipprer Canal

Hiking Trails

Rosalie Creek

MAP 4

Joe Overstreet Road and Landing, Kenansville, FL
(Osceola County)

Turkey Vulture feeding adjacent to the landing

MAP 4

Site Specifics:

Joe Overstreet Road and Landing, 4900 Joe Overstreet Road, Kenansville FL.

Hours and Fees: There are no set hours and no entry or parking fees; this is a county dirt road. Fees and hours of operation were current at the time of publication but subject to change; check the website for updates.

DESCRIPTION:

Joe Overstreet Road and Landing is a dirt road through a few ranches that ends at a boat ramp. It seems an odd hotspot for photography, but it is a must-visit for anyone in central Florida. Typically, there are Sandhill Cranes in the fields along both sides of the road; at times, there are also Whooping Cranes. Caracara is routinely on the fence posts and Bald Eagles are also prevalent.

Numerous songbirds and migrants are in the bushes and trees along the road-side. I frequently see Loggerhead Shrikes on the fencing. Hawks are frequently on the telephone poles and flying over the ranch fields.

Wading birds, such as egrets, herons, and Limpkins are common near the Landing. Turkey Vultures are also common. The Endangered Snail Kite is frequently seen flying low over the water.

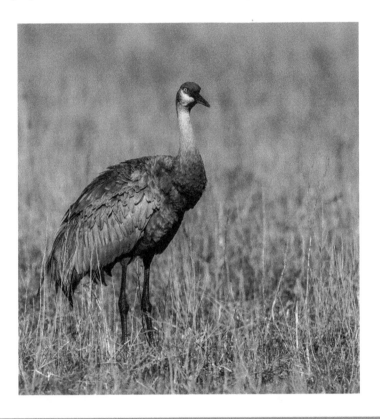

MAP 4

📷 Site Specific Photography Tips

Early mornings and late afternoons yield the best activity. Many times, you can photograph the birds from the comfort of your vehicle. The road is lightly traveled, and the road shoulder is sufficiently wide for your vehicle. The ranches are private, but I have never encountered any problems shooting from the roadside.

I use a 100-400mm lens for birds in flight. I use this same lens for Sandhill Cranes and some of the other larger birds. I switch to the 600mm for small birds.

For the Snail Kites, I use a 600mm, at times with a 1.4X teleconverter, on a Wimberley tripod head with a sturdy tripod. I know others that handhold the 600mm with excellent results for Snail Kites. If you have a boat, excellent images can be had near the shore of the Snail Kites, otherwise, you will be shooting from the shoreline.

Gatorland, Orlando, FL
(Orange County)

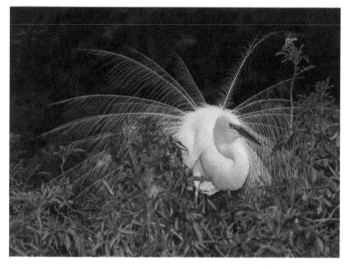

Great Egret displaying

Site Specifics:

Gatorland, 14501 South Orange Blossom Trail, Orlando, FL. Telephone: 407-855-5496. Website: https://www.gatorland.com/

Fees: Single-day admission for adults is $26.99 and children are $16.99; an adult annual pass is $44.99; a senior annual pass is $39.99, and a child annual pass is $29.99. A single-day photographer's pass is available (permitting 7 am entry). It would be best to inquire with staff about current restrictions and availability before planning your visit.

Hours: 10 am to 5 pm, 7 days a week. Fees and hours of operation were current at the time of publication but subject to change; check the website for updates.

DESCRIPTION:

An alligator farm may seem an unusual place for a wildlife hotspot, but numerous roosting and nesting birds use alligators for protection from other predators. Gatorland consists of a 110-acre park and wildlife preserve.

MAP 4

There are many captive animals, but most wildlife enthusiasts and photographers will be most interested in wild animals. Many boardwalks travel over and adjacent to lagoons and wetlands. Numerous trees and shrubs provide abundant nesting and roosting habitat for birds. A 10-acre breeding marsh was established specifically for nesting birds.

Over 20 species of birds nest at Gatorland. Wading birds, such as Great, Snowy and Cattle Egrets, Limpkins, Tricolored and Little Blue Herons, Anhinga, cormorants, and Wood Storks are common during the winter and spring nesting season.

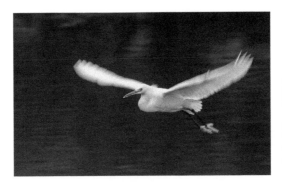

Snowy egret flying over lagoon (Photograph captured while panning with bird to show motion blur.)

📷 Site Specific Photography Tips

Photographic opportunities include both still images and flight shots. Most moderate to long telephotos work well at Gatorland. The boardwalks are steady and move very little with foot traffic. I prefer to use a tripod with my long lenses. The boardwalks are wide enough for others to pass without impeding traffic.

The best light will occur early in the day or late in the afternoon. If possible, secure a photographer's pass for the best opportunities. Not only will you arrive during the best light, but you will also have many hours before the general public arrives giving you ample time for some excellent images.

Gatorland

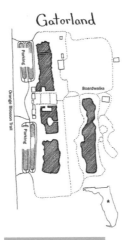

MAP 4

HOTSPOT #37

Lake Apopka Wildlife Drive, Apopka, FL (Marion County)

American Coot feeding in a roadside canal

Site Specifics:

Lake Apopka Wildlife Drive, 2850 Lust Road, Apopka, FL. Telephone: 386-329-4404. Website: https://www.sjrwmd.com/lands/recreation/lake-apopka/wildlife-drive/

Hours and Fees: Friday-Sunday and Federal Holidays: entry permitted 7 am -3 pm and must exit by 5 pm. There are no admission or parking fees. Fees and hours of operation were current at the time of publication but subject to change; check the website for updates.

DESCRIPTION:

The wildlife drive is located along the north shore of Lake Apopka and is a one-way narrow road that begins at Lust Road and ends on Jones Avenue. The drive meanders adjacent to levees and wetland ditches, lakefront areas, and marsh areas.

The speed limit is 10 mph; RVs and trailers are prohibited on the drive. The road is wide enough for cars to pass each other, provided the lead car pulls to one side. The density of traffic can be heavy.

The density of coots and moorhens is high with an abundance of egrets and herons. The diversity of birds is truly amazing. Over 360 species of birds have been recorded on the property and the 1998 Christmas Bird Count recorded 174 species, a record count for an inland area.

MAP 4

In addition to birds, raccoons, otters, coyotes, turtles, alligators, and snakes are observed. Black Bears and bobcats are occasionally observed. The best seasons for wildlife viewing are autumn, winter, and spring, especially early morning, and late afternoon.

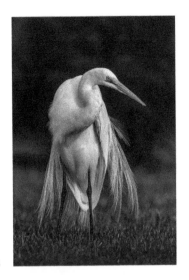

Great Egret in grass

📷 Site Specific Photography Tips

The beauty of Lake Apopka Wildlife Drive is that you will not need to carry your big guns far from the car. The canals, marsh, and lakes are adjacent to the roadside and there are sufficient parking turnouts to make the experience very enjoyable.

I would rate this area one of the top hotspots in Florida, certainly the top spot in the center of the state. The canals have a gentle slope making images close to the water possible. Do watch for alligators.

The moorhens and coots are particularly active. A patient photographer will have many activity shots in a short duration, including coots running on water. Flight photography is also productive as many Glossy and White Ibis and Great Egrets are flying from spot to spot.

Most telephoto lenses will be good. I prefer my 600mm as it allows me to isolate the birds from the background and also gives me sufficient working room to not "crowd" the birds. However, I also enjoy sitting on the canal bank with a 100-400mm lens.

MAP 4

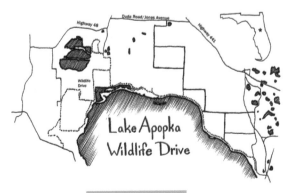

Lake Apopka
Wildlife Drive

HOTSPOT #38

Ocala Wetland Recharge Park, Ocala, FL (Marion County)

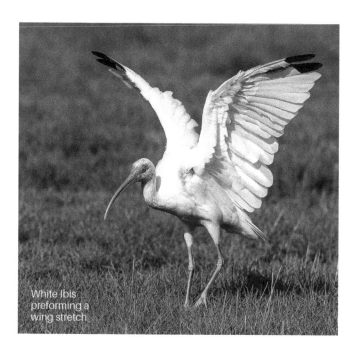

White Ibis preforming a wing stretch

Site Specifics:

Ocala Wetland Recharge Park, 2105 NW 21st Street, Ocala, FL. Telephone: 352-351-6772. Website: https://www.ocalafl.org/government/city-departments-i-z/water-resources/ocala-wetland-recharge-park

Hours and Fees: Monday-Saturday: Sunrise to sunset. There are no admission or parking fees. Fees and hours of operation were current at the time of publication but subject to change; check the website for updates.

DESCRIPTION:

Ocala Wetlands is a relatively new facility that consists of 60 acres of trails and ponds or cells. The trails include the Alligator Loop (0.86 miles), the Apple Snail Loop (0.7 miles), and the Bullfrog Loop (0.66 miles). The trails are asphalt and in excellent condition.

MAP 4

Three boardwalks cross the ponds, and three observation platforms extend over the ponds for wildlife viewing. Both the platforms and the boardwalks are approximately three feet over the water surface.

Alligators and squirrels are relatively common; bobcats are occasionally seen. Numerous birds use the wetland. An amazing number of small birds were near the parking area. Water-loving birds predominate near the ponds. These include herons (Great Blue, Little Blue, Green, and Tri-colored), egrets (Snowy, Great, and Cattle), ibis (both Glossy and White), ducks (Northern Shoveler, Blue-winged Teal, and Black-bellied Whistling), Gallinule (Common and Purple), Hooded Merganser and Pied-billed Grebe, American Coots and Anhinga.

Upland birds and raptors include woodpeckers (Red-headed, Pileated, and Red-bellied), Red-winged Blackbirds, Red-tailed Hawks, and American Kestrels. Numerous sparrows, warblers, and other songbirds are resident in the oaks and shrubs.

📷 Site Specific Photography Tips

The pond shoreline is gradual, making the approach easy. Vegetation is healthy but not so thick that photography is impossible. Moderate to long telephoto lenses will be effective for capturing most of the birds in the water.

The songbirds were less habituated and more difficult to photograph. A 600mm lens with a teleconverter may be required to get frame-filling images.

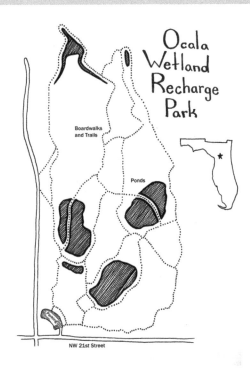

Ocala Wetland Recharge Park

Boardwalks and Trails

Ponds

MAP 4

NW 21st Street

Homosassa Springs and Homosassa Springs Wildlife State Park, Homosassa Springs, FL (Citrus County)

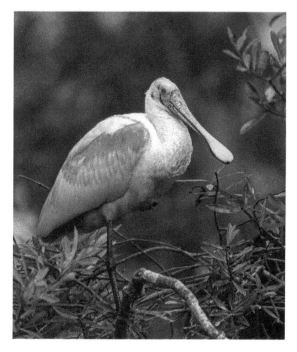

Roseate Spoonbill perched on limb of shrub

MAP 4

Site Specifics:

Ellie Schiller Homosassa Springs Wildlife State Park, 9350 West Fishbowl Drive, Homosassa Springs, FL, and 4150 South Suncoast Boulevard, Homosassa, FL. Telephone: 352-628-5343. Website: https://www.floridastateparks.org/parks-and-trails/ellie-schiller-homosassa-springs-wildlife-state-park

Fees: Admission fees for children (13+) and adults are $13, children 6-12 are $5, and children under 5 are free. Admission is free for those with a valid Florida State Park annual pass.

Hours: The park is open from 9 am to 5:30 pm, 365 days per year. Fees and hours of operation were current at the time of publication but subject to change; check the website for updates.

DESCRIPTION:

Homosassa Springs Wildlife State Park is a 210-acre park that consists of crystal-clear spring water and 1.1 miles of trails (paved and boardwalk). There are two entrances, one with a visitor center that is located off US 19 (4150 South Suncoast Boulevard) and a second with a café located off Fishbowl Drive. These two entrances are connected by the Pepper Creek Trail.

The park serves as a rehabilitation center for orphaned or injured manatee. Other captive animals, that are unable to return to the wild, are on display including River Otters, Key Deer, alligators, Red Wolves, Whooping Cranes, bobcats, Florida Panther and Black Bears.

Numerous wild animals are present including Roseate Spoonbills, Wood Storks, Wood Ducks, herons, egrets, and numerous manatees. An underwater observatory provides an up-close view of fish and manatee. Numerous manatees are visible from the elevated boardwalks over the river.

Swimming with the manatees is also permitted outside the park boundaries. Concessionaires provide equipment and round-trip travel to the diving area. Alternately, you may also bring your kayak, canoe, or paddleboard to access the water.

📷 Site Specific Photography Tips

A moderate telephoto zoom lens will be ideal for photography along the trail and within the park. Unless it is heavy overcast, I carry my camera setup and do not use a tripod. There are plenty of railings within the park to steady the camera and I found the light level sufficient along the trail. See Hotspot #41 for recommendations related to underwater manatee photography.

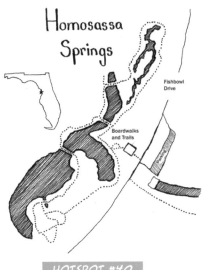

Homosassa Springs

Fishbowl Drive

Boardwalks and Trails

MAP 4

HOTSPOT #40

Three Sisters Springs, Crystal River, FL (Citrus County)

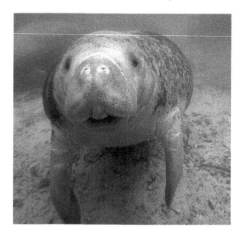

Manatee swimming at Three Sisters Spring

Site Specifics:

Three Sisters Spring Center, 123 NW Highway 19, Crystal River, FL. Telephone: 352-586-1170. Website: https://www.threesistersspringsvisitor.org

Fees: Fees vary depending on the time of year. Winter adult rates are $20, seniors are $17.50, the military is $15, and children 6-15 are $7.50. Summer adult and senior rates are $12.50, the military is $11.50, and children 6-15 are $7.50. National Pass Holders and Federal Duck Stamp holders receive a $5 discount for adults, seniors, and the military. There are also special rates for Citrus county residents and annual passes for frequent visitors.

Hours: The park is open from 8:30 am to 4:30 pm. In-water access may be restricted during the winter season by the FWS (U.S. Fish and Wildlife Service) if the Gulf temperature dips below 62.2 F. Fees and hours of operation were current at the time of publication but subject to change; check the website for updates.

MAP 4

DESCRIPTION:

Three Sisters Spring and nearby Homosassa Springs (see hotspot #40) are advertised as the only places in North America to legally swim with the manatee. This is an experience that should be on every person's bucket list. There are numerous concessionaires providing boat access to the manatee area. You may also bring your canoe, kayak, or paddleboat. No motorized vessels are permitted.

Scuba, snorkel, or free diving is allowed but I found that snorkel equipment was more than sufficient. The manatees are docile, and you will be able to approach within a few feet of these gentle giants. There is a roped-off area where humans are not permitted, and this contains a larger concentration of manatees; however, plenty of manatees venture out of the roped area and swim among the humans.

The water is clear and the depth ranges from a few feet to nearly 10 feet.

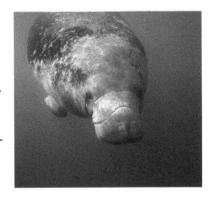

Manatee swimming at
Three Sisters Spring

📷 Site Specific Photography Tips

Some form of camera protection will be needed, such as an EWA camera housing or an Ikelite housing. EWA is more budget-friendly with prices in the $300 range for specific cameras. An Ikelite housing starts at approximately $1,600 plus accessories.

Good quality, fast, wide-angle lenses are traditionally used for underwater photography. Because of light loss, loss of contrast, and debris in the water, you will be photographing manatees very close, usually less than 24 inches. Preset all your controls from the safety of the boat; once in the water, it will be more difficult to change ISO, aperture, shutter speed, and other functions.

More light will penetrate the water on clear days, but a bright overcast day is also a good option. Heavy overcast days will not have sufficient intensity for underwater photography. Flash equipment is prohibited at Three Sisters.

When photographing the manatee, try not to kick your fins much as this will stir up the bottom muck that clouds the water. I prefer to photograph them away from most other tourists as the water is also less turbulent.

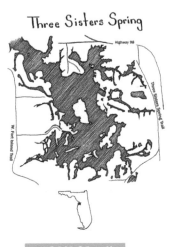

Three Sisters Spring

MAP 4

Cedar Key Scrub State Reserve & Cedar Key, Cedar Key, FL
(Levy County)

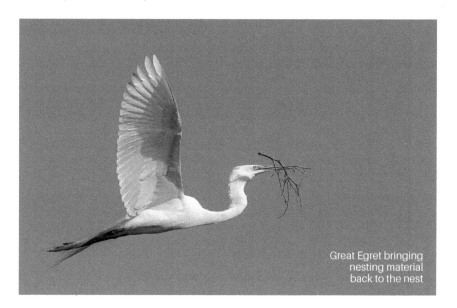

Great Egret bringing
nesting material
back to the nest

Site Specifics:

Cedar Key Scrub State Reserve, 8312 SW 125th Court, Cedar Key, FL and Cedar Key Beach Access, 1st Street at A Street, Cedar Key, FL. Telephone: 352-543-5567. Website: https://www.floridastateparks.org/parks-and-trails/cedar-key-scrub-state-reserve

Fees: No entrance fees are charged at the reserve and no parking fees are charged for public parking in Cedar Key.

DESCRIPTION:

Cedar Key Scrub State Reserve consists of approximately 5,000 acres and over 13 miles of trails suitable for hiking, bikes, and horse-back riding. The primary habitat of the reserve is Florida scrub that provides a critical area for the endangered Florida Scrub-jay, Gopher Tortoise, and Florida Mouse.

MAP 4

If you are looking for an area to get away from "it all", this preserve is the place. There is a small parking area with picnic tables on CR 347. The reserve borders both sides of County Route 347.

The western boundary of the reserve is a tidal marsh with an abundance of wading birds. Although relatively rare, the salt marshes are the best location to observe the Scott's Seaside Sparrow and Marian's Marsh Wrens.

Continue west along the tidal marsh and you will come to the quaint city of Cedar Key. Osprey and Brown Pelicans are common in the lagoons; wading birds and shorebirds are common in the tidal areas and on the public beach.

Cedar Key is also an excellent area for seafood as many of the fishermen sell directly to the restaurants.

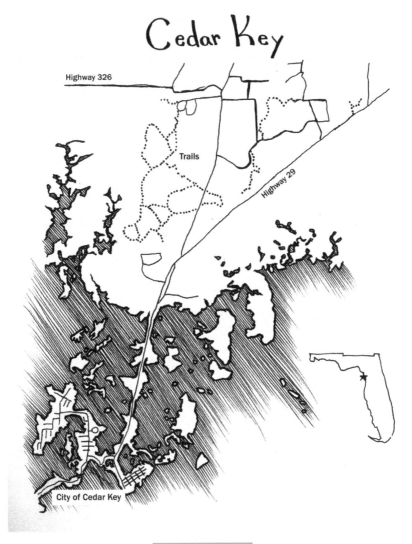

Cedar Key

Highway 326

Trails

Highway 29

City of Cedar Key

MAP 4

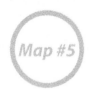

Map #5

NORTH AND PANHANDLE REGION
COVERING HOTSPOTS #43-50

North and Panhandle

Paynes Prairie Preserve State Park, Micanopy, FL
(Alachua County)

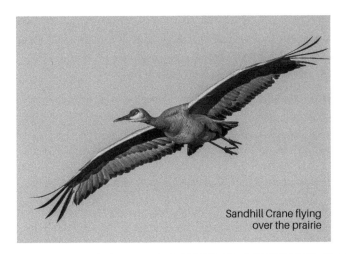

Sandhill Crane flying
over the prairie

Site Specifics:

Paynes Prairie Preserve State Park, 100 Savannah Boulevard, Micanopy, FL. Telephone: 352-466-3397. Website: https://www.floridastateparks.org/parks-and-trails/paynes-prairie-preserve-state-park

Fees: Park entrance requires payment of a fee that depends on the number of occupants in your vehicle. As of 2021, entrance fees for one person per vehicle are $4, two to eight persons in a single vehicle are $6 and pedestrians or bicyclists are $2. An annual state parks pass is available for Florida Parks; it is an excellent value if you plan many visits to the state parks.

Hours: The park is open from 8 am to sunset, 365 days per year. Fees and hours of operation were current at the time of publication but subject to change; check the website for updates.

DESCRIPTION:

Paynes Prairie Preserve State Park consists of 22,000 acres of savannah, marsh, lakes, and wetlands; it became the first state preserve in 1971. Seven trails explore various areas of the preserve.

MAP 5

It is the only location in Florida to observe wild bison and wild horses. The horses are descendants of those released by the Spanish explorers. The bison were introduced in 1975.

In addition to bison and horses, the preserve is host to approximately 270 species of birds. Alligators, otters, deer, bobcats, tortoises, and many other animals call the preserve home.

Gopher Tortoises are most common on the Lake Trail. Wild horses are most common on the Bolen Bluff Trail; bison are also possible in the area. Bison also frequent the southern end of the preserve.

From mid-October to mid-November, hundreds of migratory Sandhill Cranes arrive at Paynes Prairie. These can be best observed on the La Chua Trail. Large alligators are also best viewed on the La Chua Trail.

In addition to Bolen Bluff (2.5-mile), Lake (0.8-mile), and La Chua (3-mile) Trails, the remaining trails include Chachala (6.5-mile loop), Cones Dike (8 miles), Jackson's Gap (1.2-mile), Ecopassage Observation Boardwalk, and the Gainesville-Hawthorne State Trail (16-mile).

📷 Site Specific Photography Tips

Early mornings and late afternoons are best for wildlife and landscape photography. The park entrance opens at 8 am but some of the trails are accessible without entering the main entrance.

Because of the trail lengths, I typically use a single-camera body and a 100-400mm telephoto zoom lens on a Black Rapid Strap across my body. This makes for an efficient hiking setup.

When I need to steady my camera in lower light situations, there is usually a tree or rock nearby. If I am in the open prairie areas, I can sit and steady my camera on my knee or lie on the ground and use my elbows.

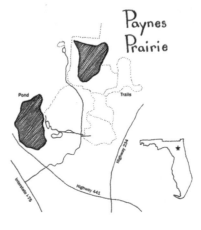

MAP 5

Sweetwater Wetlands Park, Gainesville, FL (Alachua County)

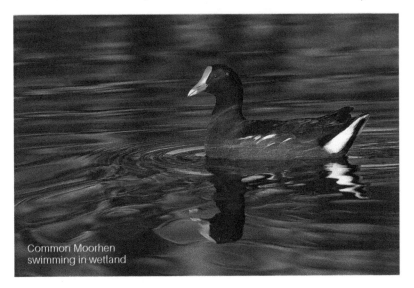

Common Moorhen swimming in wetland

Site Specifics:

Sweetwater Wetlands Park, 325 SW Williston Road, Gainesville, FL. Telephone: 352-554-5871. Website: https://www.sweetwaterwetlands.org/

Fees: Park entrance is $5 per car and $2 for pedestrians and bicyclists. An annual pass is available, but the pass is specific for this park.

Hours: The park is open from 7 am to sunset, 365 days per year. Fees and hours of operation were current at the time of publication but subject to change; check the website for updates.

DESCRIPTION:

Sweetwater Wetlands Park, managed by the City of Gainesville, is located just north of Paynes Prairie Preserve. The park consists of 125 acres of ponds and wetlands interconnected by land bridges.

A 3.5-mile boardwalk connects limestone trails over the wetland areas. The park is home to approximately 215 species of birds. Alligators are common. On occasion, wild bison and wild horses from adjacent Paynes Prairie Preserve have been observed.

MAP 5

Sweetwater Wetlands Park is a hidden gem that is known to locals but unknown to most outside the area. This is an excellent area for viewing and photographing wildlife. Because of the low boardwalks, shallow approaches to the wetlands, and the wide-open areas, viewing and photography are very enjoyable.

Wild Bison
eating grass

📷 Site Specific Photography Tips

Boardwalks range from a foot to three feet above the water surface. Photography from the boardwalks is great in the areas where the boardwalk is close to the water. There are numerous gravel paths. It is possible to approach the edges of the ponds from these paths; however, watch for alligators.

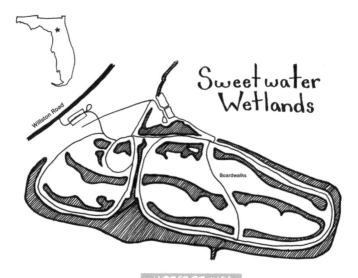

Sweetwater
Wetlands

Williston Road

Boardwalks

MAP 5

108

HOTSPOT #44

Alligator Lake Park, Lake City, FL (Columbia County)

Marsh Rabbit feeding along the trail

Site Specifics:

Alligator Lake Park, 420 SE Alligator Glen, Lake City, FL. Telephone: 386-719-7545. Website: https://www.columbiacountyfla.com/ParksandRecreation.asp

Fees and Hours: There are no entry fees and no parking fees. Park is open Tuesday through Sunday from 8 am to 7 pm and winter hours are 8 am to 5:30 pm. Park is closed on Monday. Fees and hours of operation were current at the time of publication but subject to change; check the website for updates.

DESCRIPTION:

Alligator Lake Park consists of approximately 1,000 acres of oaks, cypress, pines, palmettos, and wetlands. It is restored agricultural land that has been converted to wetlands with a recreational focus.

Extensive hiking trails weave through the park area. These trails include the Old Canal (0.9 miles), Deer (0.4 miles), Possom Trot (0.5 miles), Bobcat (0.4 miles), Eagle (0.4 miles), Willow Pond (1.1 miles), Capybara (1.2 miles), Egret Loop (2.0 miles), and James H. Montgomery (3.0 miles). There is a canoe and boat ramp near the Montgomery Trail.

MAP 5

Wildlife is abundant and includes Marsh Rabbit, Gopher Tortoise, White-tailed Deer, armadillo, alligators, and bobcats. Wading birds are abundant in the shallow wetlands, especially along the James H. Montgomery Trail.

I was amazed by the density of wildlife along the Montgomery Trail about an hour before sunset. Parts of the trail are covered by a canopy of trees and Marsh Rabbits are dense. Numerous Tricolored and Great Blue Herons were observed in the wetlands.

📷 Site Specific Photography Tips

The Marsh Rabbits are a bit skittish but if you remain still and somewhat concealed, they will return from the edge shrub cover to feed on the grass along the trail. I prefer to take shots low to the ground, at the animals' eye-level. Using a blind or hind increases your opportunities. Telephoto lenses of 300mm and above will yield frame-filling images.

Also, bring a wide-angle lens for the landscape images. The cypress and oak canopy over the Montgomery Trail in the late evening light is particularly beautiful.

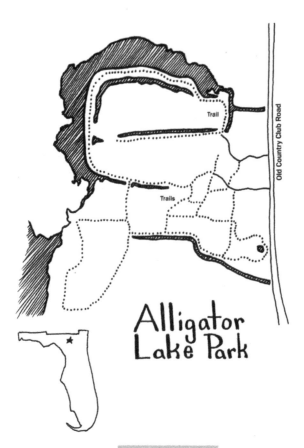

Trail

Old Country Club Road

Trails

Alligator Lake Park

MAP 5

Suwannee River State Park, Live Oak, FL (Suwannee County)

Wood Duck swimming in still water

Site Specifics:

Suwannee River State Park, 3631 201st Path, Live Oak, FL. Telephone: 386-362-2746. Website: https://www.floridastateparks.org/parks-and-trails/suwannee-river-state-park

Fees: Park entrance requires payment of a fee that depends on the number of occupants in your vehicle. Entrance fees for one person per vehicle are $4, two to eight persons in a single vehicle are $5 and pedestrians or bicyclists are $2. An annual state parks pass is available for Florida Parks; it is an excellent value if you plan many visits to the state parks.

Hours: The park is open from 8 am to sunset, 365 days per year. Fees and hours of operation were current at the time of publication but subject to change; check the website for updates.

MAP 5

DESCRIPTION:

Suwannee River State Park consists of 1,800 acres surrounding the Suwannee River. There are six hiking trails, a campsite with 30 RV sites, a boat launch, and cabins for rent.

Five of the hiking trails (Big Oak, Earthworks, Lime Sink Run, Balanced Rock, and Suwannee River) are adjacent to the river and transverse dense forest consisting of oaks, cypress, and scrub. These trails are excellent for landscape and macro photography, in addition to the occasional wildlife image.

The Sandhill Trail is separate and crosses oak and scrub over sandy terrain. The Sandhill Trail is a good area to spot Gopher Tortoises.

Wildlife includes fox, Gopher Tortoise, White-tailed Deer, numerous songbirds, woodpeckers, hawks, and Wood Ducks. The greatest concentration of wildlife will be seen floating down the river in a canoe or kayak.

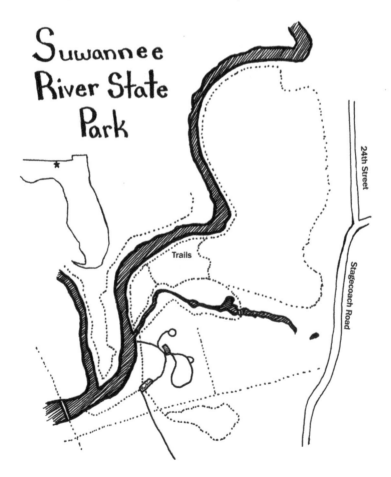

MAP 5

HOTSPOT #46

Panhandle Barrier Islands: St. Joseph Peninsula State Park, St. George Island State Park, and St. Marks National Wildlife Refuge

Wilson's Plover walking on the beach

Site Specifics:

St. Joseph Peninsula State Park, 8899 Cape San Blas Road, Port St. Joe, FL. Telephone: 850-227-1327. Website: https://www.floridastateparks.org/parks-and-trails/th-stone-memorial-st-joseph-peninsula-state-park

St. George Island State Park, 1900 E. Gulf Beach Drive, St. George Island, FL. Telephone: 850-927-2111. Website: https://www.floridastateparks.org/parks-and-trails/dr-julian-g-bruce-st-george-island-state-park

Fees for St. Joseph and St. George: Park entrance requires payment of a fee that depends on the number of occupants in your vehicle. Entrance fees for one person per vehicle are $4, two to eight persons in a single vehicle are $6 and pedestrians or bicyclists are $2. An annual state parks pass is available for Florida Parks; it is an excellent value if you plan many visits to the state parks.

Hours: The park is open 8 am to sunset, 365 days a year.

MAP 5

St. Marks National Wildlife Refuge, 1255 Lighthouse Road, St. Marks, FL. Telephone: Website: https://www.fws.gov/refuge/st_marks/

Fees: A daily pass for cars and motorcycles is $5; bicycles and pedestrians are $1. An annual pass is available and National Park Annual Passholders receive free admission.

Hours: The refuge is open Monday-Wednesday and Friday 8 am to 4 pm, Saturday and Sunday 10 am to 5 pm.

Fees and hours of operation were current at the time of publication but subject to change; check the website for updates.

DESCRIPTION:

Because of their similarities and proximities, these three sites have been grouped as a single hotspot. Each consists of coastal sand beaches, dunes, and marsh areas. All have been extensively reshaped by recent hurricanes.

Each site has hiking trails in addition to other amenities. Wildlife is also similar with raccoons, bobcats, Gopher Tortoises, wading birds, and shorebirds. Numerous shorebirds nest on these beaches beside the sea turtles. Sea turtles visit these sites in the late spring to lay eggs in the beach sand.

Birding is excellent during fall migration as these areas are stopover points for birds after a long ocean migration. Particularly after a cold front, the opportunities for birding and photography are excellent.

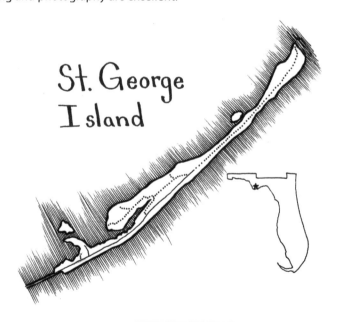

St. George Island

MAP 5

114

HOTSPOT #47

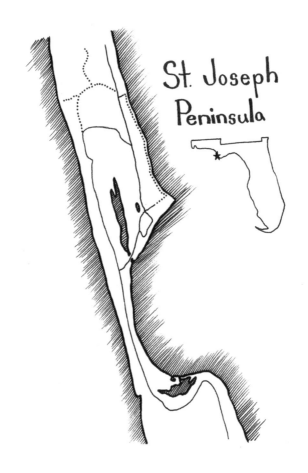

St. Joseph
Peninsula

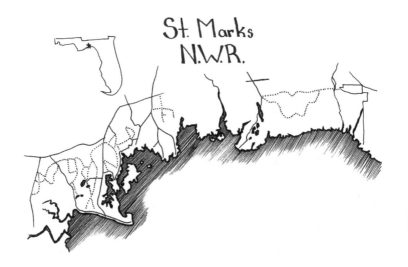

St. Marks
N.W.R.

MAP 5

Blackwater River State Park and Ft. Walton and Destin Beaches

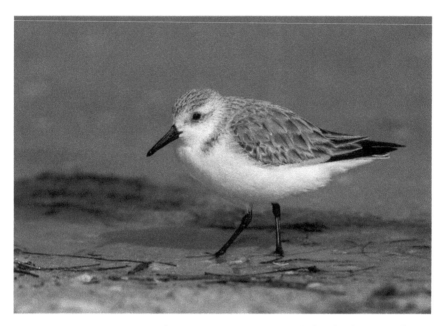

Sanderling feeding on the beach

Site Specifics:

Blackwater River State Park, 7720 Deaton Bridge Road, Milton, FL. Telephone: 850-983-5363. Website: https://www.floridastateparks.org/parks-and-trails/blackwater-river-state-park

Fees: Park entrance requires payment of a fee. Entrance fees are $4 per vehicle with a limit of eight persons, and pedestrians or bicyclists are $2. An annual state parks pass is available for Florida Parks; it is an excellent value if you plan many visits to the state parks.

Hours: Park hours are 8 am to sunset, 365 days a year.

Ft. Walton-Destin Beaches, US 98, Ft. Walton and Destin, FL

Fees: Ft. Walton-Destin beach parking is $1.50 per hour or $8.50 daily.

Fees and hours of operation were current at the time of publication but subject to change; check the website for updates.

MAP 5

116 HOTSPOT #48

DESCRIPTION:

Blackwater River State Park consists of 590 acres of pine woodlands. The river has white sand beaches, sandbars, and dark tannic waters. Canoes, kayaks, and tubes are a great way to explore the river and riverbanks.

Two hiking trails, the Chain of Lakes Nature Trail and the Juniper Lake Nature Trail, follow part of the river and part of the woodland area. The largest Atlantic White Cedar in the state is located adjacent to the river.

Wildlife includes bobcats, turkeys, White-tailed Deer, and occasionally River Otters and alligators. Birds include Mississippi Kites, warblers, hawks, and the Red-headed and Pileated Woodpeckers. The endangered Red-cockaded Woodpecker is also found at this park.

Seven pine trees are banded on Boat Ramp Road that parallels the entrance road. Travel past the entrance road for one block and turn east on Boat Ramp Road. The first banded trees are approximately one block to the east and additional banded trees are in the next half-mile. The Red-cockaded Woodpecker is frequently seen on these trees in the early mornings.

Ft. Walton and Destin's beaches span 24 miles; these are white-sand beaches with emerald, green water that is fed by the Appalachian River from the Appalachian Mountains. Shorebirds, gulls, and terns are relatively common on the beaches. Occasionally, wading birds are also fishing for a meal in the surf.

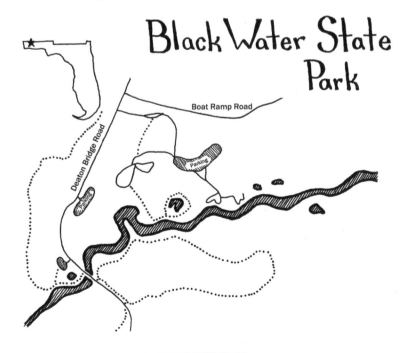

Black Water State Park

Boat Ramp Road

Deaton Bridge Road

Parking

MAP 5

Little Talbot Island State Park, Jacksonville, FL (Duval County)

Willet walking on beach in early morning light

Site Specifics:

Little Talbot Island State Park, 12157 Heckscher Drive, Jacksonville, FL. Telephone: 904-251-2320. Website: https://www.floridastateparks.org/parks-and-trails/little-talbot-island-state-park

Fees: Park entrance requires payment of a fee that depends on the number of occupants in your vehicle. Entrance fees for one person per vehicle are $4, two to eight persons in a single vehicle are $5 and pedestrians or bicyclists are $2. An annual state parks pass is available for Florida Parks; it is an excellent value if you plan many visits to the state parks.

Hours: Park gates open at 8 am and close at 5 pm, 365 days. Fees and hours of operation were current at the time of publication but subject to change; check the website for updates.

DESCRIPTION:

MAP 5

Little Talbot Island consists of five miles of beach and hiking trails. The Dune Ridge Trail (4 miles) crosses parts of the north end of the island. The boardwalks over the dunes are also wildlife-rich areas; many times you will find a Gopher Tortoise adjacent to the boardwalk.

The primary wildlife of the island are armadillos, raccoons, Marsh Rabbits, Gopher Tortoises, snakes, opossums, and occasionally bobcats. Sea turtles nest on the island beaches in the spring.

The predominant avian life of the island shoreline are shorebirds. Wading birds are relatively abundant in the marsh area on the backside of the island. The island hosts many nesting shorebirds in the spring, overwintering shorebirds from late summer to spring, and seasonal migrants.

Nesting shorebirds include American Oystercatchers, Willets, Wilson's Plovers, Black Skimmers, and Least Terns. Prime nesting season is from April to September. Overwintering shorebirds, such as the protected Piping Plovers, arrive around August and remain until early spring. Migrants include Red Knots, Painted Buntings plus numerous songbirds.

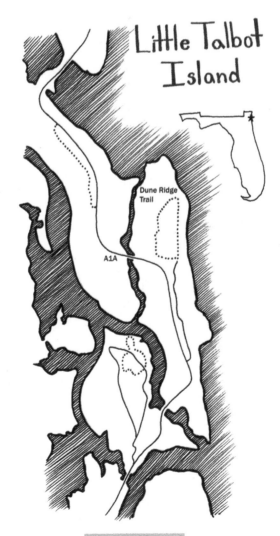

St. Augustine Alligator Farm, St. Augustine, FL (St. Johns County)

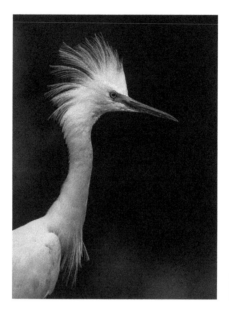

A portrait of a Snowy Egret in breeding plumage

Site Specifics:

St. Augustine Alligator Farm, 999 Anastasia Boulevard, St. Augustine, FL. Telephone: 904-824-3337. Website: https://www.alligatorfarm.com/

Fees: Daily admission is $27.99 for adults (12 and greater) and $16.99 for children (ages 3-11). Individual annual passes are $109.95 (family passes are also available) and an annual photography pass is $119.95. The photography pass permits early 8 am entry and late exit from mid-March to mid-July.

Hours: The alligator farm is open daily from 9 am to 5 pm with extended summer hours, 9 am to 6 pm. Fees and hours of operation were current at the time of publication but subject to change; check the website for updates.

DESCRIPTION:

MAP 5

The St. Augustine Alligator Farm is one of the oldest established zoos as it was founded in 1893. There are numerous alligator and crocodile exhibits in addition to a Birds of Africa exhibit, Galapagos Tortoises, Lemurs of Madagascar, Sloths, and a Komodo Dragon.

The Alligator Farm is also prime habitat for wading birds at the native bird rookery. Birds nest in the vicinity of alligators for protection from climbing predators such as raccoons. Wading birds that nest at the rookery include Green, Tri-colored, and Little Blue Herons, Great, Snowy, and Cattle Egrets, Roseate Spoonbills, and Wood Storks.

Non-nesting native birds include Yellow-crowned and Black-crowned Night Herons, White Ibis, and Great Blue Herons. The following Rookery Schedule was provided by the staff at the alligator farm:

February-March: Great Egrets arrive and begin nesting; Great Egrets begin hatching out late March. Roseate Spoonbills and Wood Storks also begin nesting activity.

April: Wood Stork chicks begin hatching. Smaller herons, such as Snowy, Tri-colored, and Little Blue begin laying eggs. Roseate Spoonbills begin hatching about mid-April and Snowy chicks start hatching in late April.

May-June: Green Heron chicks start hatching out in early May and the Great Egret and Wood Stork chicks are growing quickly.

July-August: Most chicks are fledglings, and many begin to leave the nest. Nesting season is complete in August except for a few stragglers.

📷 Site Specific Photography Tips

Generally, the larger wading birds will nest further from the boardwalk, usually in the trees at the apex of the rookery. Many smaller birds will nest very close in the shrubs that border the boardwalk.

Most telephoto lens will be effective at capturing a variety of nesting birds. The best light will be early in the day and late in the afternoon. Especially for the white birds, such as Wood Storks, Great Egrets, White Ibis and Roseate Spoonbills, softer morning and evening light is so beautiful and complementary to the birds.

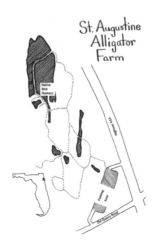

St. Augustine Alligator Farm

MAP 5

About the Author

Moose Henderson is an award-winning wildlife photographer, scientist, and conservationist. In his youth, he operated a traditional photographic studio doing portraits, weddings, pets, aerials, and commercial/industrial photography. Photographing people was not a passion, so he focused his attention on wild animals. He has photographed wildlife and nature throughout North America, Europe, and Asia. He spent two years in Siberia photographing endangered cranes, storks, and other wildlife.

As a scientist with a doctorate specializing in moose ecology, a master's in wildlife biology, and a bachelor's in environmental geology, he uses his knowledge of animals and animal behavior to capture their true essence. He describes his style of photography as "visceral." Using eye contact, perceived danger, light, color, or atmospheric moods, he seeks to produce images that evoke an emotional response.

His images are distributed by stock agencies (Alamy, Windigo Images, and Getty) with over 11,000 published credits in some of the most prestigious periodicals. Published credits include National Geographic, Smithsonian, Outdoor Photographer, and many others.

Moose lives in the Greater Yellowstone Ecosystem near Jackson, Wyoming. He frequently travels to other locations around North America, Europe, and Asia for dynamic photographic images. Moose is a member of North American Nature Photographers Association (NANPA), Professional Photographers of America (PPA), Art Association of Jackson Hole (AAJH), Teton Photography Group, and the Shoot to Care Campaign for ethical wildlife photography.

KAREN DOODY, F.PH.

Karen Doody is an award-winning professional photographer, member of the Professional Photographers of America and the Professional Photographers of North Carolina. Schooled in photography, she made her living as a graphic designer for over 20 years. In 1997 she became a scuba instructor and worked as an underwater photographer before her desire to create beautiful images led her back to terra firma where she runs a successful wedding photography business and continues to pursue her passion for nature and wildlife photography.

JOANNA WALITALO

Joanna Walitalo grew up in Oil City, MI, going to Bullock Creek High School, where she took art classes taught by Mr. Mathern and Mr. Myers; both very talented artists, and teachers with endless patience. She earned a BS in Biology and Environmental Studies from Central Michigan University, and took art classes at the Midland Center for the Arts, where she had the opportunity to study under Armin Mersmann. While studying at CMU, she took art classes from Dietmar Krumrey II and Michael Volker. From there, she moved to the Upper Peninsula of Michigan where she earned a Master of Forestry at Michigan Technological University. A strong love of the outdoors, and wild places, has led her to incorporate her passion for art with her professional education, to bring the beauty of wildlife and wild places closer to the general public through scientifically accurate artwork. By far, the artist that influenced Joanna the most throughout her life has been her mom, Barb Rogers, who worked as an Art Teacher at Coleman Middle School, MI, for many years, and always encouraged and guided Joanna to incorporate art into all her endeavors. Today, Joanna continues to live with her loving husband James, and son Little James, in Michigan's Upper Peninsula, working as an artist and illustrator.

MY FIELD NOTES:

Other Books by Sastrugi Press

50 Wildlife Hotspots Grand Teton National Park
by Moose Henderson

Find out where to find animals and photograph them in Grand Teton National Park from a professional wildlife photographer. This unique guide shares the secret locations with the best chance at spotting wildlife. You will find exactly where and when to go to find the animals you are looking for.

2024 Total Eclipse State Series by Aaron Linsdau

Sastrugi Press has published state-specific guides for the 2024 total eclipse crossing over the United States. Check the Sastrugi Press website for the available state eclipse books:

www.sastrugipress.com/eclipse.

Jackson Hole Hiking Guide by Aaron Linsdau

Find the best hiking trails in Jackson Hole. You'll get maps, GPS coordinates, accurate routes, elevation info, highlights, and dangers. The guide includes easy, challenging, family-friendly, and ADA-accessible trails and hikes. Whether you are an avid hiker looking for a multi-day adventure or have a family with young children, this book has what you want. There are walks for everyone in this guide.

Voices at Twilight by Lori Howe, Ph.D.

Voices at Twilight is a guide that takes readers on a visual tour of twelve past and present Wyoming ghost towns. Contained within are travel directions, GPS coordinates, and tips for intrepid readers.

Visit Sastrugi Press on the web at www.sastrugipress.com to purchase the above titles in bulk. They are also available from your local bookstore or online retailers in print, e-book, or audiobook form.

<div align="center">

Thank you for choosing Sastrugi Press.
"Turn the Page Loose"

</div>

Milton Keynes UK
Ingram Content Group UK Ltd.
UKHW022223180823
427045UK00005B/94/J